Virginia
HORSE RACING

Virginia
HORSE RACING

TRIUMPHS
OF THE TURF

VIRGINIA C. JOHNSON
AND
BARBARA CROOKSHANKS

Charleston London

THE
History
PRESS

Published by The History Press
Charleston, SC 29403
www.historypress.net

Cover image: *Peytona and Fashion: in their great match for $20,000. over the Union Course L.I. May 13th. 1845, won by Peytona, time 7:39¾ 7:45¼.* Currier & Ives. Courtesy of the Library of Congress.

First published 2008

Manufactured in the United States

ISBN 978.1.59629.439.4

Library of Congress Cataloging-in-Publication Data
Johnson, Virginia C.
Virginia horse racing : triumphs of the turf / Virginia C. Johnson and Barbara Crookshanks.
p. cm.
ISBN 978-1-59629-439-4
1. Horse racing--Virginia--History. I. Crookshanks, Barbara. II. Title.
SF335.U6V575 2008
798.409755--dc22
 2008022645

Dedicated to our husbands and fathers

 V.C.J. and B.C.

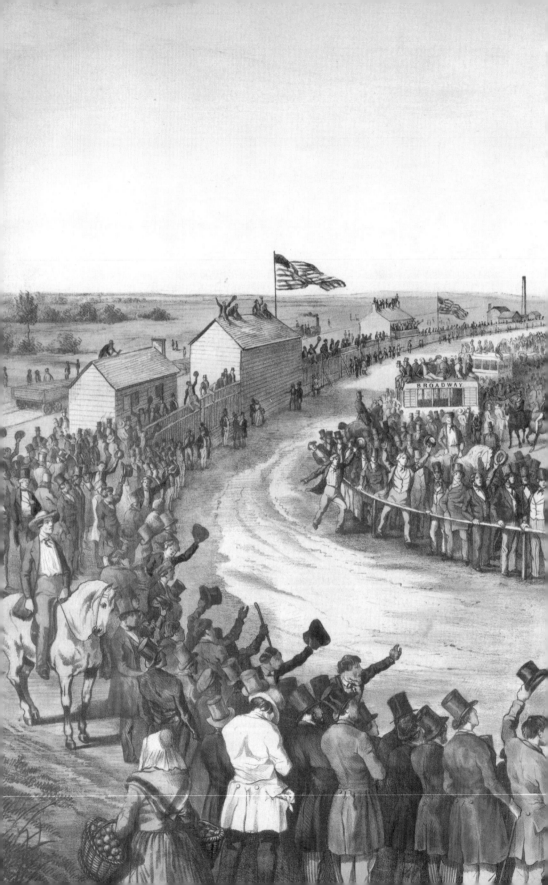

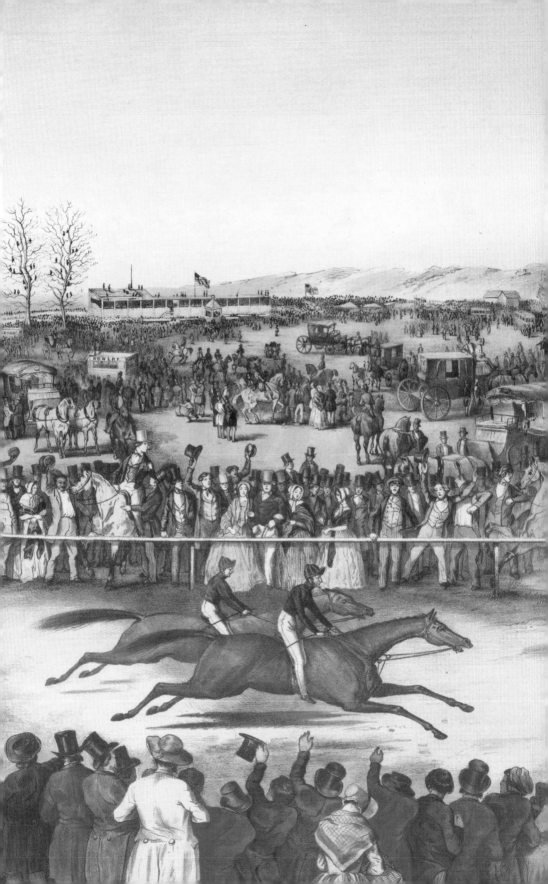

Contents

Acknowledgements

Lisa Campbell, librarian, the National Sporting Library

Claiborne Farm

Colonial Williamsburg Foundation

Vernon Creekmore

Mandy Duckworth, librarian, L.E. Smoot Memorial Library, King George
County

Fredericksburg Area Museum and Cultural Center

The Garden Club of Virginia

Chuck Gray, librarian, Central Rappahannock Regional Library

Judith S. Hynson and Gretchen Goodell, Stratford Hall

Shannon K. Luce, the Jockey Club

Margaret M. O'Bryant and Bruce Keith, Albemarle-Charlottesville
Historical Society

Craig L. Orndorff, Belle Grove Plantation

Howell W. Perkins, Virginia Museum of Fine Arts

Donald Pfanz and John Hennessy, Fredericksburg and Spotsylvania National
Military Park

Susan A. Riggs, librarian, Swem Library, the College of William and Mary

Paula M. Tignor, Union Bank and Trust, Bowling Green

The Virginia Historical Society

And these turf historians, without whom this book could not have been
written: James Douglas Anderson, Fairfax Harrison, John Hervey,
Alexander Mackay-Smith, Baylie Peyton and William H.P. Robertson

Introduction

Pounding hooves, the call of bugles and resounding cheers echo across the centuries in Virginia, from Tidewater to Southside and on to the Piedmont and the Shenandoah. They remind us of the Old Dominion's golden days of horse racing.

Today the asphalt river we call Interstate 95 gives little indication that much exists beyond its views of modern shopping malls and subdivisions. At rest stops, visitors can pick up brochures for Mount Vernon, the National Park Service's Chatham, the James River Plantations, Stratford Hall and many more sites. But few realize that these relics of times past share a common history—that their owners were friends and competitors in that jubilant, maddening sport that captured the imaginations and fortunes of its enthusiasts. The sport was horse racing, and Virginia was its glorious center for breeding and racing during the colony and state's first centuries.

Although an interest in blooded horses never really left Virginia, the majority of Thoroughbred breeding and racing operations had relocated to Kentucky by the end of the nineteenth century. But in 1973, a huge, chestnut colt named Secretariat left the nation amazed at his Triple Crown wins in blazing time. Secretariat was foaled in Virginia, and he, like so many other stakes winners before him, traced his lineage to early Virginia sires and dams.

The names Selima, Diomed, Medley, Sir Archie and Boston should not be forgotten, though they raced over a hundred years ago. Their legacies can be found racing down the backstretch of every American track. Their owners and breeders staked their money, their personal pride and their region's

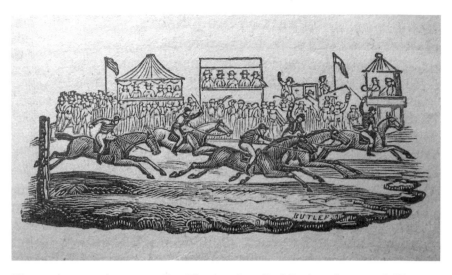

Nineteenth-century horse race. *From* The American Turf Register, Sportsman's Herald and General Stud Book.

reputation on galloping testaments to fine breeding, excellent training, equine courage and sheer racing luck.

What this book attempts to do is pull back the curtain on those long-ago times when people traveled hundreds of miles to witness their favorites in contests of speed and endurance. From the first ill-fated equines to set hooves on Jamestown's raw streets to pastures past and present where clean-limbed, noble animals graze freely, the story of Virginia's horses is one that should not only be written on the wind, but also remembered and savored when exploring the state's historic resources.

Virginia's First Runners

Nearly four centuries ago, six mares and a stallion arrived at Jamestown in 1611 and were greeted eagerly by the starving settlers, who used them for food rather than racing them.

When Sir Thomas Dale arrived in 1611, he found the Jamestown colonists to be in wretched physical shape, but this did not prevent them from using what strength they had to enjoy a bit of sport—some choosing to bowl in the streets rather than attending to hard work. Dale, an English soldier on extended leave from the fighting in Holland, used a harsh discipline with both the colonists and the surrounding Indian tribes to enforce English rule on the land.

Disease, Indian attacks and starvation took a continuous toll, but the colony thrived and spread through the virgin wilderness. During the following decade, the next importations of horses fared better. These later years, 1618–23, were called the Great Migration, in which Jamestown's human population increased from 400 to 4,500 colonists, and equine settlers were welcomed, too. The twenty mares imported by the Virginia Company in 1620 were described as "beautiful and full of courage."

Dale founded a new city named Henricus farther up the James River. Soon tobacco fields began to make money for the colonists. In time, the area around Henricus, and later Richmond, would be famous for its racecourses.

With the starving times not quite behind them, in 1613 the Virginia General Assembly gave special privileges to colonists who chose to breed horses and sheep, but that growth was slow to come. By 1649 there were

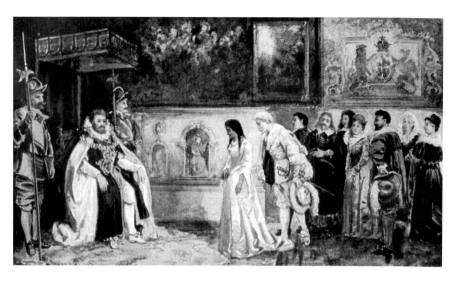

Pocahontas at the court of King James, by Richard Rummels. *The Jamestown Amusement & Vending Company, 1907. Courtesy of the Library of Congress.*

no more than two hundred horses and mares in the colony. But soon horse breeding and interest in formal racing would expand, and both because of the loyal connection Virginians felt to a king returned from exile.

THE CAVALIERS

Were there death in the cup,
Here's a health to King Charles!
–from "Glee for King Charles," by Sir Walter Scott

Virginia has been called "the Cavalier Country" for its beginnings as a place where English nobility's sons and daughters came to settle. These staunch supporters of the Stuart kings found themselves at war and adrift during Oliver Cromwell's English Commonwealth (1649–60) and many migrated to the Old Dominion, a nickname Virginia carries to this day in homage to its loyalty to the Stuarts.

In King Charles I's England these cavaliers had personified elegance. Mounted on blooded horses, they dressed in silk and velvet. Wide-brimmed plumed hats topped their long, curled hair. They fought Cromwell valiantly, if in vain.

Virginia's First Runners

In Virginia, far from home and trying to recreate a sense of it in the new land, they became soldiers, explorers, merchants and landholders, all the while keeping their British customs. On their farms and plantations, they raised crops and livestock imported from their homeland. But they also took advantage of what they found in the New World. One of the gifts of the New World, by way of the Old World, was fine horses.

The English were not the only colonists to arrive on American shores. Farther south, the Spanish had made their mark, and some of the horses they brought with them were so marvelous that the English colonists were eager to acquire more of these Andalusian steeds, also known as the purebred Spanish horse or Pura Raza Española (PRE). Beautiful, stylish, brave and fast, the Andalusians traced some of their breeding to Oriental stock imported in ancient times.

Andalusians and their kin have always been prized for military maneuvers. Before the names Spain and Portugal were ever coined, the horsemen of the Iberian Peninsula were mentioned in Homer's *Iliad* and helped bring victory to Sparta over Athens in the Peloponnesian wars. Their celebrated steeds were able to both charge and stop quickly, leap and pirouette. Their descendants, the famous Lipizzaner stallions of Vienna's Spanish Riding School, give an elegant show of these horses' capabilities in warfare. When Hollywood directors want to cast beautiful horses, as they did in *Braveheart*, *The Lord of the Rings* trilogy and *Legend*, they often choose Andalusians or their relations.

In addition to the Andalusians, the Spanish also brought over more average horses. Cabeza de Vaca landed at St. Augustine, Florida, in 1527 and, after some exploration, turned the horses loose to run wild. The Native Americans gentled them in time, and these Chicksaw ponies would be another strain used to breed early native-born horses.

Other horses later imported to Virginia from desert lines would completely change the makeup of both the English and American racers, and the bloodlines of three outstanding sires would ultimately create the breed that we call the Thoroughbred.

What was the difference between these horses and those the English colonists already had in hand? Warm-blooded English horses were built for a variety of duties. These horses were generally good for war, hunting, riding and also a bit of plowing. Solid, strong and dependable, they were probably a mix of many different British breeds, but on the whole they were not bred

especially to run races. Cold-blooded, heavier horses, such as the Shire and the Suffolk Punch, were bred for the plow.

The word "Thoroughbred" today has a very specific meaning. A proper American Thoroughbred must be registered with the *American Stud Book* and have exactly the right bloodlines to qualify. In centuries past, the word Thoroughbred was not much used. Instead, horses were called "blooded" or "bred" to indicate that they were from the proper stock to be considered racehorses.

Whether the horses were properly bred or not, from the Russian steppes to the Old West and most anywhere else that people and horses got together, there would be racing. And where there was racing, there could also be drinking, dancing, gambling and other kinds of socializing. Charles II was one of the Stuart kings, that line that came to the throne after the death of Good Queen Bess. They were a contentious crew, sometimes called "the ill-starred Stuarts" for the difficulties they faced when their headstrong ways clashed with the will of Parliament and the people. Charles II would be responsible for bringing racing into vogue in both England and America.

James I, for whom Jamestown and the James River are named, came to the throne in 1603 as the first Stuart king of England. He authorized the creation of an English-language version of the Bible and ended the war with the Spanish. A complicated man, he also dismissed Parliament over disagreements, pushed for the Divine Right of Kings (he wrote some books on it) and had Sir Walter Raleigh beheaded for treason.

He was also king when the first imported desert horses came into the royal stables. Ambling Courser, one of the "Digby Arabians," was brought to England in 1617. About 1624, the Markham Arabian arrived at the Royal Stud at Tutbury (Tetbury), Staffordshire. These horses were most likely bred for general riding and warfare, not for racing. Details of the Royal Studs' activities may be found in Nicholas Russell's book, *Like Engend'ring Like: Heredity and Animal Breeding in Early Modern England.*

James I's son, Charles I, was an equally strong-minded monarch. He married a Catholic princess despite Parliament's objections and refused to accept a constitutional monarchy. He died on the executioner's block after his cavaliers were defeated by the anti-royalist Roundheads. Yet through these dark days, Virginia remained in spirit a loyal dominion to the Crown, thereby earning its nickname of "the Old Dominion." However, its designation as a commonwealth is a nod to the victorious Roundheads who ruled until 1660.

When Charles I's son, Charles II, came to the English throne, the plain and religious strictures of Oliver Cromwell were quick to be overturned. This new merry monarch returned from exile was determined to have a good time, and one of his favorite recreations was the racetrack. He patronized what was called "the sport of kings" in his honor—bringing racecourses and racehorses into fashion—and the royal colonies followed his lead.

In the wilds of Virginia, the sport took on some of the rougher aspects of the colony itself. In England, it was convenient to have races run straight through fields cleared centuries ago, but the shores of the Virginia colony were not easily available for simple recreation. The Indians practiced a kind of forest management, but the flat pieces of turf were few and far between. Clearly, for the good of the sport, some adjustments to the terrain would have to be made.

WHY RACE?

The Virginia colony was very much a business proposition. The planters were there to make money and anything taking time away from clearing the fields and planting tobacco was not something a sensible person would pursue. Yet they did. Charles II led the fashion for racing and so his courtiers and many cavalier gentlemen followed the custom. By the time of his ascension to the throne in 1660, horse breeding was getting underway in Virginia.

According to William H.P. Robertson's *The History of Thoroughbred Racing in America*, every member of the first King's Council that governed Virginia had either owned or bred racehorses at home in England before coming to America. For them it was a part of home and perhaps they saw it as a necessary luxury. Certainly they seem to have maintained their enthusiasm for the sport, as one of the council's first acts was to pass a statute forbidding racing down the newly cleared streets.

Bancroft's *History of the United States* stated that, in 1656, "The horse was multiplied in Virginia, and to improve that noble animal was an early object of pride favored by legislation. Speed was especially valued."

AMERICA'S FIRST RACECOURSE

The first true American racecourse was not in Virginia. That honor goes to New York. The first racecourse was laid out on New York's Long Island in 1665 by its first English royal governor, Colonel Richard Nicholls. Colonel Nicholls was quite the cavalier. He had been groom of the bedchamber to King Charles II's younger brother James, later to be crowned James II. This course was laid out for racing on the island's convenient plain during his first year in office. Governor Nicholls announced that as a prize for the first race, he would give a silver cup, in the manner of the English plate races.

This track was first called Salisbury Plain, after another area famous for both its racing and its ancient British monument, Stonehenge. For his efforts, Nicholls became known as "the Father of Racing in America." The course would survive through several centuries, with the name changing to New Market (after another famous English course) and later to Washington Race Course. In those early days, it was popular with cavaliers, including some transplants and visitors from the Virginia colony.

RACING THROUGH TOWN

But back in Virginia, horse racing had to take a rougher approach, at least in the beginning. It demanded a lot of work to hack out proper race fields in the startup colony. In the beginning, the settlers simply didn't try. But they did adapt. There were some straight thoroughfares through the streets of Jamestown, later in Williamsburg and virtually in any other settlement of size. These could be and were adapted to some quick racing. While most settlements had racing, Williamsburg was particularly lucky both in its location—a bit removed from the mosquito-ridden swamps of Jamestown—and by having as its leading citizen a man who loved learning, the Lord and the layout of a good racecourse. His name was James Blair.

Although the College of William and Mary began in 1693 with a mission to educate new ministers for the colony, the Reverend Doctor James Blair, its first president, also had secular interests. He was what was commonly called in England a sporting parson. But he did not confine his interests to

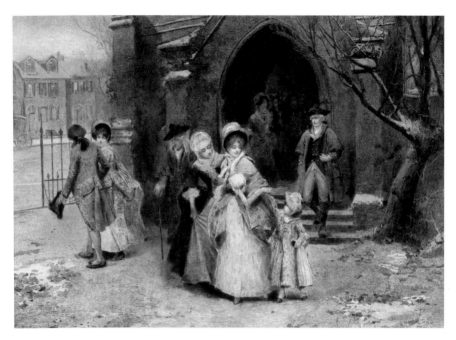

Colonial Days, by James S. King. *Courtesy of the Library of Congress.*

the college and the racetrack. Dr. Blair was also the highest dignitary of the Established Church in America, president of the Council of Virginia and for a time acting governor, having succeeded in having another governor fired. Yet all of these serious duties did not lessen the Scotsman's passion for the races. His insistence that Williamsburg take Jamestown's place as the capital of Virginia—which it did in 1699—gave racing a leg up.

With Williamsburg the new center of social and political maneuverings for the colony, racing was a preferred indulgence for the colony's gentlemen leaders. The reverend found himself in court quite a bit during these years—not for any of his own troubles but because he was considered a high authority on matters of the track. He was often called upon to officiate in races and later testify in civil court. Many of the horses' owners landed there because of wild behavior—more so from the humans than the horses themselves. Once street racing was officially outlawed, colonists again managed to keep their horses and their society exercised by means of quarter path racing.

THE QUARTER PATH AND THE QUARTER HORSE

As street races were banned, it behooved the colonists to find another way to try their horses and place their bets.

Not having been blessed with much terrain naturally suited to racing, Virginians carved paths through the wilderness. As they were only a quarter of a mile long, they were dubbed quarter paths. Many of the horses that vied to show their opponents their heels along these rugged raceways would someday be found in the pedigrees of the modern American Quarter Horse.

So, how was a quarter race run? In the usual course of events, a gentleman would declare that his horse or mare could take on any neighborhood contender and he would put up a purse of money to back his claim. Soon enough, another gentleman would take him up on it, staking his own funds, which might be cash or tobacco. Spectators would join in with side bets. Then the time and place would be set. Paths were often found at a crossroads near a tavern, courthouse or church.

John Hervey described the scene beautifully in his landmark book, *Racing in America*:

> *The race path was a narrow strip of ground, about fifteen to twenty feet wide, and from a quarter of a mile to 500 yards long, perfectly straight and with room at one end for two opponents to get off and at the other to pull up—this being no great space, as one of the most indispensable attributes of the Quarter Horse was his ability to whirl and get off at top speed in two strides and to come to a stop from full flight with equal facility…*
>
> *The start of the quarter-race was supposed to be a standing one, but the two contenders, rearing and circling at the scratch, in reality took off flying. The "jockeying" for the advantage here was one of the great sights of the sport. Both horses and riders were trained to maneuver in the most spectacular way and the outcome often depended upon which got the best of the break and was able to seize the preferred strip of the path. If well matched the two would run the entire course closely locked, which led to the claims of crossing, jostling and fouling often brought up in the suits-at-law that were so frequently the aftermath.*
>
> *The firing of a pistol, blast of a trumpet, or tap of a drum was the signal to break and the exacting and ungrateful office of the starter then*

as now was one only to be entrusted to a man thoroughly two-fisted and well able to handle the situation. At the coming-out place the endman was stationed to decide the winner.

Doubtless the quick reflexes and intelligence of the Andalusians gave them and their get an advantage in these contests. The racers who excelled became known as quarter horses, perhaps the first truly American breed. But by 1750, the quarter paths had changed to routes of a mile or more, and so had the abilities of the horses that ran on them. When longer distances became the standard, most quarter horses were pushed out to the frontier. There, their extreme versatility allowed them to pull extra duties as stock horses and saddle horses.

Yet in these early years of the colony, the quarter path and its quarter horses were the standard for sportsmen. Quarter Horses are easy to spot among any breed, for their characteristics have not changed much since the eighteenth century. Powerful hindquarters, small, compact bodies, neat pasterns and brightly turned countenances are some of the hallmarks of the Quarter Horse.

A brilliant runner might gain such a reputation in his neighborhood that no one was willing to challenge him. He might develop so much fame that no one in the surrounding counties was willing to take him on, either. What was an owner to do, then? One tried method was to disguise the horse, running him under another name, in another county to try to make some coin. A horse racing under these shady conditions was called a ringer.

A Sport Only for Gentlemen

Racing between colonists of all sorts may have happened in the valleys and backcountry roads of Virginia quite a bit, but proper racing could only be conducted by gentlemen—a word that had a legal definition at the time. Simple good manners were not enough to qualify. A gentleman, according to English law of the period, was born of noble family or of the landed gentry. Landed gentry were those who were untitled but lived off the proceeds of their large landholdings.

According to York County, Virginia court records, in 1674,

> *James Bullocke, a Taylor, having made a race for his mare to runn w'th a horse belonging to Mr. Matthew Slader for twoe thousand pounds of tobacco and caske, it being contrary to Law for a Labourer to make a race, being a sport only for Gentlemen, is fined for the same one hundred pounds of tobacco and caske.*
>
> *Whereas Mr. Matthew Slader and James Bullocke, by condition under the hand and seal of the said Slader, that his horse should runn out of the way that Bullocke's mare might win, w'ch is an apparent cheate is ord'ed to be putt in the stocks and there sitt the space of one houre.*

So Mr. Bullocke, the tailor, got the heavy fine and the embarrassment of sitting in the stocks. Mr. Matthew Slader, the gentleman who planned the "cheate," simply received a humiliating hour in the stocks. In those days, two thousand pounds of tobacco was a considerable sum, so the tailor's crime of jumping above his lowly rank's privileges merited a severe punishment indeed. Laws continued to favor the wealthy. By 1713, Virginia law prohibited men who did not own land from likewise owning horses or mares for breeding.

Rank did have its privileges, and a day at the racecourse amongst one's social equals was one of them. The diaries of prominent Virginians such as Robert "King" Carter and George Washington contain notes of days at the races and sums lost and won. And although colonial gentlemen were the only ones permitted to own racehorses, the races were by no means the exclusive domain of the gentry.

According to Hervey, in the days of quarter racing, booths were set up near the start of the path for even a one-day event. Ordinary observers—and there were many—might enjoy food and drink, have their fortunes told or browse for small gifts among the many vendors. He described how wilderness hunters clad in deerskin, military officers, artisans, laborers, the ruling class, house servants, slaves, sailors and Indians would gather together for entertainment at what amounted to a one-day fair.

After the solemn tap of a drum or a bugle's blast gave the signal to start, the horses would run on two distinct but parallel paths. However, one of the two routes was always preferred. So at that wild start, horses would

plunge and wheel, and jockeys would try hard-handed tactics to force their opponents from the best course. Occasionally overly enthusiastic spectators and owners would also do their best to foul them from the beginning. This frontier-style sport filled colonial Virginia's courts with lawsuits from furious owners.

JANUS

Although the English racehorse Janus was not imported into the colony until relatively late, he should be mentioned here because more than any other horse he passed on the gift of powerful hindquarters, high speed, high intelligence and all the characteristics that go into making a top Quarter Horse. He doesn't show up in many Thoroughbred pedigrees, but many modern registered Quarter Horses trace their ancestry to him.

Janus's story is certainly an intriguing one. He was foaled in 1746, a son of Benjamin Rogers's bay colt, also called Janus, who was in turn a son of the famous Godolphin Arabian. In England, he raced under the name Little Janus from 1751 to 1753. He was marked with a narrow blaze, one white hind foot and a speckled rump.

He was brought to Virginia in 1756 by Mordecai Booth of Gloucester County and was later bought by John Willis of Brunswick County sometime before 1761. He was quite small, standing only fourteen hands and three-quarters of an inch at the withers, making him a pony and not a horse by today's standards. The ten-year-old chestnut raced victoriously several times in Virginia before being retired to stud for having developed a "foul sinew." Lest readers think he was only a sprinter, it is important to note that one of those victories was against Valiant, an import owned by William Byrd III of Westover over several heats of four miles each.

Janus stood as a sire in Tidewater Virginia and later south of the James River. Eventually he moved down to North Carolina, where quarter racing was still popular. The stallion died in 1780 at the age of thirty-four, having had a tremendous impact on American horse breeding, although his most famous descendants will be found among the Quarter Horses, not the Thoroughbreds.

THE KNIGHTS OF THE GOLDEN HORSESHOE

On a sultry August day in 1716, Virginia's Royal Governor Alexander Spotswood led a remarkable expedition on horseback down the streets of Williamsburg and out to the far Blue Ridge Mountains. No English explorer was known to have gone so far into the western hills. It was Spotswood's idea to discover the lay of those unknown lands and reckon their potential for future settlement.

As he rode along with his men, he was joined by additional adventurous horsemen until their number became more than sixty. Adventurous, yes, but also privileged, they traveled with their comfortable provisions neatly tucked away on pack mules that were led by servants. Their last point of contact with civilization was Germanna, part of Spotswood's landholdings on the edge of what was known as "the Spotsylvania Wilderness."

They were prepared to hunt and saw much game: deer, huge elk and pheasant. When the party reached Swift Run Gap, they were over 2,300 feet higher than their Tidewater homeland. They settled in for a bit, drank special toasts to the health of King George and Governor Spotswood and decided to name two of the mountains in their honor. They rode down to the banks of the Shenandoah River, where they celebrated with more toasts of wine, brandy and claret. On its banks, they buried a bottle with paper declaring that the whole valley belonged to "George I, King by the Grace of God of Great Britain, France, Ireland and Virginia."

A curious custom among early Tidewater Virginia horsemen led to the expedition's name. These horses were not routinely shod, for wrought iron was expensive and rare, while Tidewater soil is sandy and soft—quite easy on the hooves. The explorers' horses, bound for the rugged mountains, had to be shod at the last minute, so Governor Spotswood with a bit of humor decided to call his company "the Knights of the Golden Horseshoe." The governor gifted his men with tiny mementoes of the expedition: small golden horseshoes set with garnets. On them was inscribed in Latin, "*Sic jurat transcendere montes*," which translates into English, "Thus he swears to cross the mountains."

Upon their return, Alexander Spotswood was knighted for his efforts at furthering Virginia's exploration. He became a very rich and powerful landowner and set up an ironworks at Germanna staffed by German immigrants specially brought over to work the forge.

Virginia's First Runners

The fame of the Knights of the Golden Horseshoe lives on in what was once Virginia's western reaches. Eighth graders in West Virginia take a standardized test to prove their knowledge of the state's history. The competition is called the Golden Horseshoe in honor of Spotswood's trek. The highest-scoring students are "knighted" at the state capitol in Charleston and receive a token for their hard work: a golden horseshoe of their own.

The Spotswood family went on to prosper in the colony. Besides profiting from sweet tobacco and wrought iron, they also raised fine blooded horses during the heyday of Virginia's Racehorse Region.

Improving the Breed

To understand the colonial and antebellum equine worlds, it is important to understand their terminology. Today the term "horse" is used by many people to describe anything on four legs that whinnies. If people want to get particular, they believe that a small "horse" is called a pony and a newborn is a foal. But this is not proper horsespeak. A horse to a horseman is something very specific—it is a male equine four years or older that has not been gelded. A mare is similarly four years and older but female. A filly is a female equine younger than four years, and a colt is a male that is younger than four. A gelding has been castrated, either to make him easier to handle or because he isn't worthy to pass on his genes to the next generation. In old parlance, a gelding may also be called an unsexed horse.

You may read that a horse stands so-and-so many hands. A hand measurement equals 4 inches, approximately the width of a person's hand. A horse is not measured to the top of his head but to the top of his withers—that part of the animal that is just beyond the front of the saddle, at the start of the neck. Each inch up to the 4 is listed as .1, .2 or .3. As an example, an 18.1 hand horse is really huge and measures 72 inches plus 1 inch, or a touch over 6 feet at the shoulder. Equines are judged to be ponies if they measure 14.2 hands or less.

The Near Eastern horses of Arabia and North Africa, which added so much to the colonial racing stock, were relatively small. They had delicate legs, wide brows, small muzzles and had been bred for generations to be intelligent, hardy and fleet. The Europeans were accustomed to breeding

horses whose height and bulk made them formidable weapons in battle. When they met the desert people and their horses, either through trade or warfare, they discovered that the fiery little steeds had much to offer a warrior—or a sportsman.

But there was no easy trade for these horses, as there were for spices and other luxury items from the East. According to John Gilmer Speed's *The Horse in America*, records going back to the fifth century show that the best quality and greatest number of Arabian horses came from an area called Nejd. Only owned by the wealthy and important persons, there were never very many of them. More significantly, the horses were rarely sold out of their territory, which explains why they did not make an earlier impact on European horse breeding.

Speed goes on to write that the Arabs were not in the habit of keeping detailed pedigrees on their horses, so the lineage of early Thoroughbred foundation sires (the Byerley Turk, the Darley Arabian and the Godolphin Arabian) would likely not have been recorded in any detail in their home countries. Their masters bred the best to the best, knowing that the result would be a worthy purebred, no matter the lack of a lengthy pedigree.

Sometimes these fine animals would be sent as royal gifts to foreign statesmen by countries such as the Ottoman Empire, which stretched from Greece to Persia even in its waning days. Thomas Jefferson received a Barb stallion named Black Sultan and two mares from the Bey of Tunis when he was president in 1806. These were sold, and the money was turned over to the treasury. Black Sultan first stood at the Tayloes' Mount Airy in Richmond County, and the two mares added significantly to American bloodlines.

The Quarter Horse developed into a uniquely American breed that is still lightning fast over short distances. Their owners value them for their courage, good sense and ability to work cattle. As the frontier extended far to the West over the centuries, the Quarter Horse followed. Although quarter races are still held today, this breed is most visible in the rodeo. The lightning speed that was tremendously important in the colonial era is now employed for cattle roping, barrel racing, trail riding and pretty much anything else its owner wishes to try.

However, the world of the gentleman's racehorse was a rarified sphere in which distinctions of wealth and privilege still held sway, after the American Revolution and most certainly before it. According to a short

work published in 1795 by the Frenchman Moreau de Saint-Mary, entitled *Horses in America: Essay on the Manner of Improving the Breed*, there were considered to be four principal classes of horses: the racehorse, the hunter, the coach horse and the cart horse.

As Moreau explained, the racehorse was the direct result of a Barbary or Arabian horse crossed with an English mare "of the first blood." The hunter was a cross of racehorse and a mare with "three-quarters blood" but more strongly limbed than a racehorse. For the coach horse, also much beloved for wartime service, a stallion of the hunter type might be bred to yet a coarser mare with less Oriental blood in her veins. A cart horse would be heavier yet, probably crossed with a draft breed—"one of the strongest mares of York-Shire, Lincoln-Shire, Northampton-Shire, &cc, &cc, &cc."

Moreau cautioned the gentlemen of the young country "whose principles are its greatest ornament" not to breed racehorses, as they were so impractical and had led to the ruin of many fine English families: "Race horses, being adapted neither to the chase nor war and having been often the cause of ruin of the most respectable families in England, cannot, according to good morals be encouraged under a government whose principles are its greatest ornament."

Besides discouraging racehorse breeding, Moreau was strongly opposed to employing sires who were either foul-tempered or traveled from county to county to be bred, as one could never be sure of his colts' abilities or dispositions. American breeders broke these rules in spades, and wretched tempers have been part of the psychological makeup of some of the best racehorses to this day. Consider Boston and Man o' War—truly fantastic racers and sires, but both are known for their rotten dispositions.

Moreau's ideal horse was "light but not gigantic, a fine figure, with a small square head, short ears, a bold front, a brown full eye with little black spots, very open and large nostrils...a great space from the lower part to the extremity of the withers which ought to be prominent and very high, the forelegs thick and broad from the shoulder to the knees, and from the knees to the joints next to the foot, lean and flat."

Whether Moreau's suggestions were taken seriously or not, he wrote much during his travels—including a remarkable description of the voodoo dances of Haiti—and apparently impressed the Emperor Napoleon Bonaparte with his worldliness and his revolutionary zeal. The French emperor from Corsica made him the governor of Parma from 1802 to 1806.

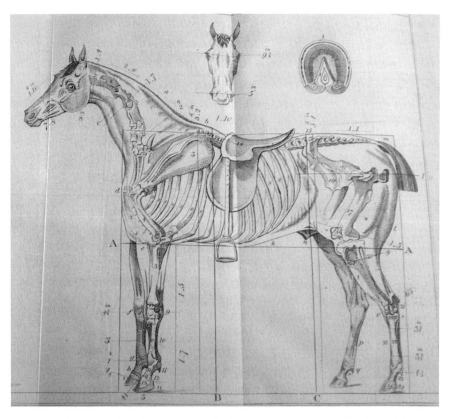

Anatomy of a horse. *From* The American Turf Register, Sportsman's Herald and General Stud Book.

The late 1500s saw significant arrivals of Eastern stallions to England. Between 1580 and 1750, approximately 150 of them were imported to that misty shore. They brought speed, beauty and endurance to every type they were crossed with, but it wasn't until the later decades that three horses would arrive on the scene to make a lasting difference. These three foundation sires—the Byerley Turk (1690), the Darley Arabian (1704) and the Godolphin Arabian (circa 1730)—form the basis of the modern Thoroughbred. All registered Thoroughbreds trace their ancestry back to one or more of these three.

What made these sons of the desert so different from their English counterparts? They were bred to the clouds, as the saying goes. For more than a thousand years, the Arabic people had maintained their purebred horses.

Improving the Breed

John Gilmer Speed remarked that, strange as it may seem, inbreeding seems to help rather than hurt the breeds such as Thoroughbreds and Morgans that are closely related to the Arabian horses. We will see that principle employed in America in the 1800s, when almost all racers carried repeated strains of the stallions Medley, Diomed and Sir Archie.

THE BYERLEY TURK: SPOILS OF WAR

The madness of war in a faraway land yielded an unexpected treasure for England. In the 1680s, Pope Innocent XI called for the formation of a Holy League to push back the Ottoman Empire from Europe. The Holy Roman Empire, headed by Habsburg Austria, joined with the Venetian Republic, Poland and Muscovite Russia to take on the Turks who had almost captured Vienna. The Holy League laid siege to the Hungarian city Buda in 1686 and triumphed there, destroying many of its medieval landmarks in the process. The war lasted for sixteen years until 1699, leaving the Ottoman Empire without several of its territories, including Hungary. The city Buda would later be combined with the adjacent city Pest to become the modern capital Budapest.

Among the troops who captured Buda was Captain Robert Byerley of the Sixth Dragoon Guards. The captain was serving under Prince William of Orange, later to be crowned William III of England along with his wife, Queen Mary II. Captain Byerley acquired a magnificent dark bay charger from a captured Turkish officer. Believed to be about eight years old at the time of the battle, the charger was swiftly put into service as the captain's war horse and occasional racer, as it is recorded that he won the top prize at Down Royal in Northern Ireland in 1690.

Captain Byerley, who followed William III to Ireland to battle against the forces of the Stuart King James II, was the son of Colonel Anthony Byerley, whose cavalry unit was known as Byerley's Bulldogs. Robert Byerley, who married the grandniece of Lord Wharton, a well-known horse breeder, put his war prize, the Byerley Turk, at stud at his Goldsborough Hall until at least 1701.

One of the Byerley Turk's best-known foals was Basto (b. 1702). Like many of his get, this one had the dark brown coloring of his sire. Another son of the Turk, called Jigg, was but a traveling sire until his son Partner proved his worth as a racer and later as a sire himself. The Byerley Turk's daughters were crucial to ennobling English racing blood. They included the Byerley

Turk Mare, who was the dam of Bulle Rock, the first "bred" horse imported to Virginia in 1730. Bulle Rock's sire was another of the Thoroughbred foundation sires, the Darley Arabian.

Besides Bulle Rock, from the American viewpoint one of the Turk's most influential descendants was Old Crabbe (1722–1750). His get were among those racehorses first imported to America, and they shared the family's rugged build. Old Crabbe's son, Mr. Routh's Crab, was imported in 1746 by John Baylor of Caroline County.

(A note on spelling: readers may find the Byerley Turk listed as the Byerly Turk, for so it was mistakenly recorded in England's *General Stud Book*.)

THE DARLEY ARABIAN: A SMUGGLED STALLION

Unlike Captain Byerley's Turk, Thomas Darley's Arabian was acquired under much more peaceful, albeit shady, circumstances. Thomas Darley was a merchant and served as Her Majesty's consul to the Levant (Syria). The story goes that he greatly admired a beautiful bay yearling and arranged to purchase him from Sheikh Mirza II of the Fedan Bedouins for three hundred golden sovereigns. At some point in the deal, the Sheikh changed his mind, but Darley remained determined.

Mr. Darley employed some sailors to spirit away the colt, and his prize arrived in England, by way of Smyrna, in 1704. According to the message Thomas sent to his brother Richard at the family home of Aldby Hall in Yorkshire, the horse was supposed to be of very pure Arabian lines, probably of a strain called "Muniqui" known for their speed.

The Darley Arabian stood at Aldby and was active as sire certainly between 1706 and 1719. A son called Bartlett's Childers, also known as Young Childers, sired many horses including Squirt, the sire of Marske, who was in turn the sire of Eclipse and he in turn the sire of the Virginia foundation horse, Shark.

Bulle Rock, the first imported blooded horse, was foaled in 1709 and is believed to have been a son of the Darley Arabian as well as a grandson of the Byerley Turk. He was called "a good Plate horse." He raced until he was nine years old in England. Bulle Rock was probably imported by James Patton, an English shipmaster. He was later owned by Samuel Gist of Hanover County, Virginia.

THE GODOLPHIN ARABIAN: THE KNIGHT OF THE WONDERFUL CREST

The Godolphin Arabian is probably the most famous of the three foundation sires, thanks in part to the Newbery Prize–winning children's book *King of the Wind* by Marguerite Henry. Foaled in approximately 1724, there is some debate as to whether he was an Arabian or a Barb from North Africa's Barbary Coast. The story goes that about 1730 he was found abused, pulling a cart on the streets of Paris, by an Englishman named Mr. Coke. Feeling sorry for the nag, he bought him for only three pounds.

By 1731, the horse was employed as a teaser stallion at Lord Godolphin's estate in England. These horses did the work of courting the mares, making them more tractable for the top studs. The managers tried him as a stallion in his own right and found that his get were remarkably wonderful on the racecourse. He was owned by Lord Godolphin. The horse in turn was the possessor of a devoted cat who appears in his portrait. The cat stayed with him until he died in 1753 and remained with his body until it was buried.

Much admired for his conformation, including the height of his crest, the Godolphin Arabian had grandsons and granddaughters that were

The Godolphin Arabian, from a painting by G. Stubbs. *From* The American Turf Register, Sportsman's Herald and General Stud Book.

imported to colonial America, including Fearnought, Vampire, Burwell's Regulus, Silver Eye and Merry Tom. His daughter Selima was truly a foundation mare for America.

Silver Eye was a pale sorrel horse with a white face, raw nose and pale-colored "glass" eyes, which probably gave him his name. He was also marked with four white stockings. Silver Eye was owned by Samuel Duval of Henrico County near Richmond. The Duvals, French Huguenot refugees, had settled there in 1700, near Manakin Town on the upper James River.

The Godolphin Arabian's amazing ability as a sire prompted noted turf historian Fairfax Harrison to declare, "There is not a superior horse on the Turf today, without a cross of the Godolphin Arabian." Indeed, his blood continued on in the champions Boston, Lexington and, much later, Man o' War and Secretariat.

IMPORTED TO VIRGINIA...

As it has been said, for more than fifty years all the best Thoroughbred stallions and Thoroughbred mares in America were owned on the plantations that lay along the James and the Rappahannock rivers or in the Carolinas.
—Charles E. Trevathan, The American Thoroughbred

In addition to the great studs and mares that will be discussed in chapter 5, there were other imports of blooded horses that played a role in diversifying and upgrading the Virginia racehorses.

In 1741, James Hoskins of King and Queen County in Virginia's Middle Peninsula imported Dabster, foaled in 1736. Dabster's grandsire was the brown horse Hobgoblin from the Godolphin Stud. Hobgoblin was a contemporary of the Godolphin Arabian, and he was also a grandson of the Darley Arabian. Dabster is considered the second blooded horse brought to Virginia, the first being Bulle Rock. The Hoskins family continued to have an interest in horses: Colonel John Hoskins (1751–1813) kept a fine stable at his home, Mount Pleasant.

Jolly Roger, by Roundhead and out of a Croft's Partner mare, was imported to Virginia about 1750. In England, he was known as Roger of the Vale. He was owned early on by Ralph Wormeley of Rosegill

in Middlesex County, although he was at stud at many farms in the Tidewater area. He finished his days in Virginia's Southside, where he was owned by James Balfour of Brunswick County. Jolly Roger died in 1772, ancient of days at thirty-one. This chestnut stallion, a grandson of the Godolphin Arabian, is considered one of the important early sires. His descendants included Symmes' Wildair and the champion filly Ruffian. Ruffian's famous match race in 1975 against Kentucky Derby winner Foolish Pleasure ended her career and her life when she broke down and had to be destroyed.

Monkey, foaled in 1725, came from the Byerley Turk line. He is known to have raced successfully at England's Newmarket course and Knavesmire, York. He was owned and bred by the third viscount of Lonsdale.

Nathaniel Harrison (1703–1791) of Brandon in Prince George County imported Monkey to Virginia in 1747. The bay horse was at stud in Virginia until he was sold to an owner in North Carolina. He died in 1754 after siring approximately three hundred foals. Brandon is located on the southern bank of the James River and is still operating as a working farm. Its grounds may often be toured in April during Garden Week in Virginia.

The first import whose lines were extensively documented was Morton's Traveller. The bay descendant of the Byerley Turk was foaled in 1746 and imported by Joseph Morton, who had founded Leedstown on the Northern Neck in 1742. Unlike many imported stallions, this one came to America as a two-year-old colt. He raced for several seasons before being retired to stud.

Upon Mr. Morton's death in 1759, Traveller was bought by the renowned John Tayloe II, who sent him to Mount Airy, his plantation in Richmond County. Traveller died in 1762, and he was sorely missed. According to John Hervey: "He was the first English horse coming into Tidewater that exercised a strong and immediate influence for improvement and his premature death was a distinct loss…His sons were the kings of the turf in their day."

He was mated with the famous imported racing mare Selima. Their three sons—Ariel, Tayloe's Bellair and Lightfoot's Partner—were proven worthies, as were Lloyd's Traveller and Silverlegs, both out of Jenny Cameron. Tayloe's Yorick, Traveller's chestnut son out of Betty Blazella, was an exceedingly fine racehorse and went on to be a popular sire. George Washington's Magnolia was a Traveller descendant, as was William Fitzhugh's Othello. Modern champions that carry his blood include Barbaro and Secretariat.

Race Days

In the early days, there were race paths cut near most settlements. At Henrico, there were at least five of them: Bermuda Hundred, Conecock, Varina, "the Ware" and Malvern Hill. Other noteworthy courses lay between the Potomac River and the Rappahannock River, along the Northern Neck. There was Coan in Westmoreland County, Willoughby's Old Field, Fairfields, Yeocomico and Scotland in Northumberland County and Smith's Field in Northampton at Rappahannock Church. On race days, gentlemen might bet huge sums, such as an entire crop of tobacco. Or, like George Washington, they might bet very little.

At Bermuda Hundred in July of 1677, a horse race was run "between Mr. Abraham Womock & Mr. Richard Ligon." At stake was three hundred pounds of tobacco. Thomas Cocke rode for Mr. Ligon. Mr. Womock chose a boy as his jockey. The starter rather muffed his duty by declaring the race a go under dubious circumstances. Dissatisfied, Mr. Cocke pulled up his horse. Mr. Womack's entry galloped on, claiming the prize. This race, like so many others, ended not on the field, but in the courtroom.

Once the vampire tobacco crop had left the fields useless for any other agricultural activity, the land might be recycled as a racecourse. The tracks would be laid out in a circuit of at least a mile, with poles marking the distances at intervals. The horses ran on grass—or turf, as they would call it—not the more modern-style dirt tracks. Somewhat later, the racecourse became known as a racetrack, and its layout became much more standardized. Today, the larger American tracks may keep a turf course for special races,

but the majority of the running is done on dirt or "skinned" tracks, which allow for faster speeds.

DANCING DAYS

As Virginia grew, so did the social activities that surrounded race days. In its heyday, the population of Williamsburg swelled from two to six thousand people during race weeks. Race meets were usually held in the spring and in the fall, at the same time the legislature met. In other cities and counties, the meets might likewise correspond to spring and fall court dates, for court was not always in session. Balls, fine dinners, exclusive receptions and routs (another word for a fashionable gathering) filled the social calendars of the aristocracy during race week.

John Kello, writing to London from Hampton, Virginia, in 1755, noted, "Dancing is the chief diversion here, and hunting and racing." Clearly, where there were social events such as races there would also be opportunities to dance. In this way Virginia patterned itself once more on old England. Unfortunately for young men with full pockets and not much in the way of sense, gambling was also a part of the scene—and not only on horses. Cards, cockfights and boat races were ways the rich and poor might while away their time and their treasure. A 1772 diary entry from Colonel Landon Carter summed up one father's ire at his sons' gambling debts: "Burn me if I pay anything more for such sport."

Horse racing also took a toll on the family fortune, and some parents took severe steps to correct their offspring. Robert Page of Broad Neck in Hanover County made up his 1765 will, demanding that neither of his sons should be allowed to go to the horse races.

Philip Vickers Fithian, who served as tutor to horse race–loving boys at Nomini Hall, advised a friend, "But whenever you go from Home where you are to act on your own footing, either to a Ball; or to a Horse-Race, or to a Cock-Fight, I advise that you rate yourself very low, & if you bett [*sic*] at all, remember that £10,000 in Reputation & learning does not amount to a handful of Shillings in ready Cash!"

Fair Weather

Fairs were usually held twice a year and they were great opportunities for horse races. They might run three days, as did a Williamsburg fair advertised in 1737, with races held each day. Fast horses were not the only ones to win prizes. Men who danced well might win a pair of shoes, or "pumps," as they were called. Greased pigs were to be had by the swiftest, or runners might try for a pair of silver buckles.

In the days before grandstands, ladies would ride out to the course in carriages. The young blades would ride out before them, showing off their riding skills and other manly features. Visiting persons of importance might be asked to act as honorary judges and stewards, whether or not they were familiar with the rules.

During race week, the gentlemen might gather either at a private home or at a private room in a public house for evening entertainment, splitting the bill for the food, the drink and the room. Meticulous in his private record keeping, George Washington recorded that he paid out for both his share of the night's entertainments at Weedon's Tavern and a bit that he lost at cards that same night.

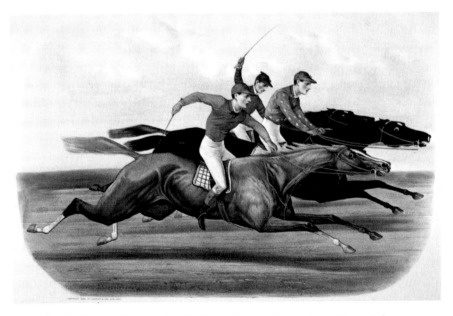

An Exciting Finish, by J. Cameron, 1884. Currier & Ives. *Courtesy of the Library of Congress.*

Peter Edwards, in his book *Horse and Man in Early Modern England*, remarks that the rise of racecourses should be seen as part of the urban cultural renaissance of the sixteenth century. A race meeting was often at the center of a whole slew of social activities designed to entertain gentry and commoners alike, albeit in different ways. The commercial influence cannot be ignored, either. Where there are travelers there must be inns and taverns. And, as the meets became more fashionable, both ladies and gentlemen from the countryside would take the opportunity to shop. A racecourse was clearly a good business proposition for a town that wished to thrive, and English colonists followed this pattern in their own towns.

But Virginians veered from adopting every English custom. They disdained certain practices, such as racing young three-year-olds over a single distance, as was done at the English Oaks and the St. Leger. Virginians liked the heroic distance of four miles in at least two heats. They also preferred to race mature horses. It wasn't until later in the nineteenth century that two-year-olds and three-year-olds were routinely run.

THE JOCKEY CLUBS

Jockey clubs were usually the organizing forces behind formal race meets. Their members were not jockeys—unless they chose to be jockeys—but rather they were the horses' owners. Later on, particularly after the Revolution, club members might hire a professional to manage the course, but the clubs themselves were exclusive. The race prizes, the entertainments and whatever else was required was financed by membership dues, approximately twenty-five dollars per member.

Unless a race was specifically labeled as open to the world, only club members could nominate or start horses, and the club members' horses would run for money put up by the members themselves. There were some open events included at meets, but the tendency was to avoid them. Match races, rare in these modern days, were an ordinary feature of the program. Entry fees could range from $25 to $500, depending on the prestige of the event, the money to be gained and the horses involved.

Racing began in the spring and then halted from July through early September. Cooler weather brought the horses out in force until the beginning of November. The clubs set the rules on weight to be carried. Typically,

younger horses were allowed lighter weights, but sometimes, according to Hervey, the young, lightweight jockeys were not strong enough to control their mounts or ride for four grueling miles, take a quick breather and then ride another four.

The gentlemen of the club often rented the use of the field from its owner, and as owners died or moved a club might change hands, change names or dissolve entirely after several years. In any case, the landowner was sometimes put in a difficult position. This announcement appeared in the Fredericksburg newspaper in the fall of 1795: "The members of the last Fredericksburg Jockey Club are again called upon to make up the sum due for the rent of their race-field, for which an execution is now over me, who contracted for the ground under their directions. The sum subscribed by some of the members is by no means adequate to discharge the debt."

Gentlemen in those times often took a hand in the training of their racers. *The Citizen and Countryman's Experienced Farrier* by J. Markham, G. Jeffries and Discreet Indians (1764) had day-by-day instructions to the gentry on how to prepare horses for racing. Particularly interesting is their recommendation for a "scour" or cleansing treatment. The scour was supposed to get rid of "all manner of molten grease and foulness whatsoever…A scour, to be given by the gentleman himself to the horse, included the best salad oil, brown sugar candy beaten to a powder, rosin, and a pint of the best sweet Sack." This was only the first scour. *The Experienced Farrier* had a whole course of them involving not just sweet sack (an imported white wine), but many other sorts of spirited liquors as well.

At the College of William and Mary, Dr. Blair certainly approved of racing as an excellent pursuit for the young gentlemen in his care, but his successor, Dr. Dawson, was not a supporter. He took a hard stance against the racing scene, issuing this resolution in 1752:

> *Yt no scholar belonging to any school in the College, or wt Age, Rank, or Quality, soever, do keep any race Horse at ye College, in ye town—or anywhere in the neighborhood—yt they be not anyway concerned in making races, or in backing, or abetting, those made by others, and yt all Race Horses, kept in ye neighborhood of ye College & belonging to any of ye scholars, be immediately dispatched & sent off, & never brought back, and all of this under Pain of ye severest Animadversion and Punishment.*

The Hoomes family, who settled in what is now Caroline County about 1675, were a mainstay of the racing scene into the 1800s. They built a racecourse on their property. Its inner circle was lined with great cedars and was maintained as long as the family owned the property. Certainly it saw a lot of use, both as a training track and as the home of the post-Revolution Virginia Jockey Club.

Races were not often recorded in the newspapers until 1750, although an advertisement did appear in December of 1739. The traces that we find before that are from court papers, which is how we know that in 1739, Joseph Hoomes's horse Blue Bonnet bested John Latham's Yellow Jacket. Mr. Latham contested, and the rivals faced each other in court, as was so often the case. Latham won the race off the track and in the courthouse.

Racing records were much better kept when the *Annals of the Turf* began publication in 1826. It was published in Southside Virginia, which was by that point the focus of Virginia's horse scene.

Today we consider a horse that wins one two-mile race in an afternoon to be a stayer, a horse with a lot of endurance. The old racers had a much more strenuous time of it. The best of them were expected to run a minimum of eight miles—two heats of four miles each, one after another. If different horses triumphed in each heat, they would go another four miles. If yet another contender took the third heat, it might go to a fourth and on very rare occasions a fifth. The mare Maria, raced by William Ransom Johnson, triumphed over unruly Duroc in a Fairfield race that lasted five full heats in 1810. It is little wonder that horses were known to break down from the strain.

By the 1750s, subscription meets could be found at many towns throughout the commonwealth. After the Revolution, courses were set near Richmond at Fairfield, Broad Rock, New Market and Tree Hill. To the west, the Winchester Jockey Club was certainly active during Virginia racing's golden age, and the war did little to dampen its enthusiasm. The club held a three-day meet at the height of the war in 1779 with purses of £600 and £350, Virginia currency, as well as a race for "country horses" with prizes to be taken from entrance fees on the previous days.

Charles Town is known for its racing today, and in the colonial and antebellum periods it had its share of race meets. Its club tried to time them so that owners could bring their horses to the gathering after the Washington City meets. But, as horseman and author Alexander Mackay-Smith noted in his book *The Thoroughbred in the Lower Shenandoah Valley, 1745–1842*, these

western races were more in the way of trials for young colts and fillies. They also served as a place for local gentry to gather.

Fredericksburg, at the headwaters of the Rappahannock, was well-known for its meets, both before and after the Revolution. The town has the distinction of having hosted the last large meet of prewar Virginia, and it nearly went to blazes because of its racing enthusiasm. A few years before the fire of 1807, Colonel Hugh Mercer, the son of Revolutionary War General Hugh Mercer, wrote to his friend, Gabriel Lewis of Lexington, Kentucky: "Our Races are just over. Our town was more crowded with company that attended than I have ever known. Colonel Seldon of Richmond, Colonel Hoomes, and Turner Dixon won the Purses which were considerable."

THE CITY BURNED WHILST THE RESIDENTS GAMBOLED

On October 19, 1807, a fire started in Fredericksburg's downtown district. It is believed by many to have begun at 1201 Princess Anne Street, a block away from what is now the public library and across the street from today's Kenmore Inn.

According to John Taylor, an agent for the Mutual Assurance Society of Richmond, it was impossible to control the fire due to high wind and the fact that "nine-tenths of the inhabitants had gone to the race fields." At this time, the race fields and fairgrounds lay at a place called "Willis's Field," just below the location of the National Cemetery. The Rappahannock Jockey Club was in charge of the proceedings. It was the successor to the Fredericksburg Jockey Club, for which George Washington served as secretary.

Someone touring Fredericksburg's Caroline and Princess Anne Streets today will find that the bulk of the buildings date from after that fire. Terrible as the Civil War was to the little town, the passion for the turf may have resulted in greater damage to its structures. By the time the volunteer fire companies gathered to fight the flames, they were too far advanced to make major progress. Three of the "best improved squares" were lost in the conflagration. The Bank of Virginia was destroyed, as were tobacco warehouses, smaller shops and homes.

A committee was formed of leading citizens to help the ravaged town. The out-of-town visitors who came to Fredericksburg for the races gave their aid, too: "The Committee take [sic] the earliest opportunity of returning

their grateful acknowledgements to those gentlemen from the country, who have, during the races, so liberally contributed to repair those ruins that they on the first alarm strove to prevent, and which were so much lessened by their efforts."

THE VIEW FROM THE PULPIT

James Blair, already noted as Williamsburg's sporting parson, certainly found no fault with a bit of spirited racing amongst gentlemen. However, this acceptance of the sport of kings did not extend to members of all sects. Many denominations found horse racing and its affiliated activities to be pathways to sin and destruction. In the colonial period, they simply would have chosen not to attend the races, which were all but officially sanctioned by the colonial government. This would necessarily cut them out of social gatherings where important business and political connections might be made.

Not all the Anglicans were happy race-goers. There were clergymen, both Anglican and in the newer denominations, who spoke up against horse racing in the colony. In 1744, the House of Burgesses had passed a law that disallowed gambling in public, but this was only enforced sometimes. William Stith, a minister of the established church, gave a grand address to a group of high-ranking Virginians. It was titled "The Sinful and Pernicious Nature of Gambling."

He appealed to the gentlemen's sense of duty to the common people: "Instead of defiling themselves with so foul a Practice, and setting Fashions to the lower People in vice, they ought by their Example to lead them on to everything that is virtuous and honest, and with the utmost Severity to restrain and punish this execrable custom."

A New Light Presbyterian minister by the name of Samuel Davies spoke on the same topic in 1756. This evangelical minister tried to make his Williamsburg listeners understand that they were "wasting the blessings of Providence."

One result of the American Revolution was the disestablishment of the Anglican Church as the official church of Virginia. Baptists', Methodists', Quakers' and Presbyterians' views on society became more important, and they did not necessarily care for the sporting scene. This meant trouble for John Broaddus of Caroline County. He was known for the excellence of his

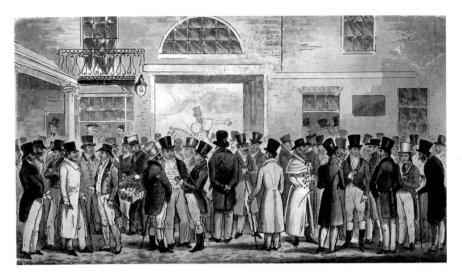

Monday after the "Great St. Leger," by R. Cruikshank, 1824. Sherwood Jones & Co. *Courtesy of the Library of Congress.*

brandy and his horses. He had bred a fine mare named Amanda, who was the granddam of the famous American Eclipse. As to his brandy, he would often say, while serving as host to his sporting friends, "Fourteen years old, and pure as the blood of Amanda." However, his minister did not share his fondness for Amanda, particularly when he found out that Mr. Broaddus had sold the mare to Wade Mosby of Powhatan County, knowing full well that she would be used for racing. So chastened was Mr. Broaddus that he refused to let his neighbor, Colonel Hoomes, buy Amanda's half-brother Algerine lest he invoke his church's wrath further.

Virginia's Bishop Meade reported that in the early 1800s the Old Dominion failed to send any representatives to the General Convention of the Church, held in New Haven in 1811. The Northern Anglican clergymen despaired of their Southern brethren, according to Meade, although the bishop was not very surprised:

> *And what could be expected from the character of the clergy generally at that time, or for a long time before? It is a melancholy fact, that many of them had been addicted to the race-field, the card-table, the ball-room, the theatre,—nay, more to the drunken revel. One of them about the very period of which I am speaking was, and had been for years, the president of a jockey-club.*

CHANGING TIMES

Between 1800 and 1830, the old turf (grass) courses were disappearing, being replaced by the "skinned," prepared track. The old courses were laid out and marked with poles for part of the way, with ropes running between them, giving a very temporary appearance. The poles and ropes were replaced with railings that would soon run the whole length of the oval track, on both sides.

Times were changing in other ways. The race fields were now being called "plants" and combined racing with other entertainments. Admission fees were charged, with an extra fee for sitting in the grandstands, although young and old blades might show off their horsemanship to ladies who were delicately ensconced in barouches, curricles or other fancy carriages.

In the colonial period, balls and dances might be held at public houses or in large private homes as part of the race week festivities. Now "the plant" would probably have exclusive clubhouses with dining rooms and ballrooms for the use of its well-heeled patrons. During the later days at New Market in Petersburg, race-goers might also try their luck at the roulette wheel.

THE JOCKEYS

Slaves would often be used as jockeys as well as trainers in the South, although many owners took an active part in their racers, training or even riding them on occasion. When slave jockeys were used in the South, their names were rarely recorded, except for the larger races. Some of the riders used a portion of their winnings to buy their freedom. More can be learned about black riders in Edward Hotaling's book, *The Great Black Jockeys*.

The 1839 contest between Virginia-bred Wagner and the Kentucky horse Gray Eagle was especially remembered by black stable hands. About ten thousand people and many out-of-town newspapermen descended on Louisville to witness the race. Wagner was the more experienced, but the gray colt was the local favorite and was handsome to behold. He would go on to be a prominent sire for saddlebred horses.

The chestnut Wagner was ridden by an extremely capable rider, a slave named Cato. A young, inexperienced white rider named Stephen Welch was aboard Gray Eagle. The gray managed a win in a hotly contested first heat.

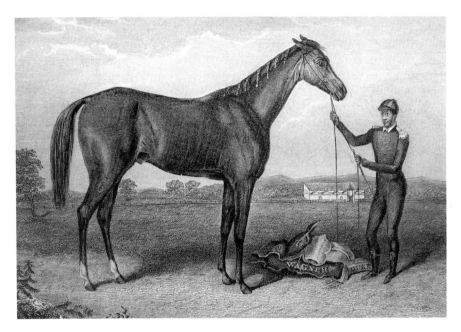

Wagner, from a painting by E. Troye. *From* The American Turf Register, Sportsman's Herald and General Stud Book.

Cato's brilliant riding guided Wagner to victory in the second heat. Gray Eagle broke down in the third heat, leaving the victory to Cato and Wagner. According to tradition, Cato received his freedom as a reward for winning this grueling race and became one of the few black jockeys mentioned by name in the *Turf Register*.

FAST TIMES AT THE NATION'S CAPITAL

John Tayloe III and General Charles Ridgeley established the first racecourse at Washington, D.C. Not surprisingly, its first running in 1798 was a match between Ridgeley's Cincinnatus and Tayloe's Lamplighter, a son of Medley. This first one-mile course was abandoned when the Frenchman L'Enfant's grand plans for the city encroached on its location.

The next Washington track was a mile oval. With no grandstand, admission was charged for vehicles entering the infield. It was a popular course, very much so with the commanders in chief as well as military heroes, visiting dignitaries, all sorts of celebrities and, of course, the local gentry.

Regular meetings were held until the British destroyed much of the city in 1814. Perhaps defiantly, the fall meet was held only two months later, but then there was a lull in racing until 1822. Racing resumed for several decades thereafter, drawing fast horses and crowds to appreciate them.

BY ANY OTHER NAME OR THE SAME

Tabasco Cat. Goose Egg. Homewrecker.

At a casual glance, the names of some modern Thoroughbreds seem truly odd. One reason for the sometime silliness is what happened in the years before there were established rules. There were at least ten horses named Eclipse, three named Diomed, ten named Traveller, four named Wildair and seven named Fearnought. If ever a great horse had progeny, the tendency was to name the colt for the old man. The same was true for mares. Besides the Godolphin Arabian's daughter Selima, who was to have such an impact on American racers, there have been fifteen others!

Today, American Thoroughbred names must be registered with the American Jockey Club. Names can only be eighteen characters long and reusing the names of famous horses such as Secretariat is largely forbidden. It wasn't so in racing's early days. This leads to puzzles for readers of early racing accounts. The owners of another day handled the situation by attaching their names to their prize horses. It was Morton's Traveller, Tayloe's Quicksilver or Ball's Florizel.

An interesting example of renaming, celebrity naming and adding the owner's name can be found in Randolph's Kitty Fisher. The gray mare was a terrific runner and the daughter of another terrific runner who was also named Kitty Fisher. As to the original Kitty Fisher, she was a beautiful courtesan who was not known for her modesty and may have enjoyed having a fast filly named in her honor, as well as the tune of a lively dance.

RUNNING FOR THE BOTTLE

There were formal horse races between gentlemen with hundreds or thousands of spectators—and then there was the other kind that happened more spontaneously at most every country crossroad.

Race Days

According to Kercheval's *History of the Valley of Virginia*, a custom kept in some settlements of the Shenandoah Valley involved a bride, a groom and a bottle. After the ceremony, usually held at the minister's house, the wedding party would ride back to the bride's home to celebrate. The young men would take off when they had only a few miles to go, riding pell-mell to be the first to grab the bottle of liquor, which was ceremoniously tied with white ribbon. The winner brought the bottle back to the rest of the party, and presented it first to the bride and then to the groom, who would pass it around for the whole company.

Come Revolution

The American Revolution brought formal racing to an end as future United States citizens gathered on the drill field rather than on the racecourse. Virginia's last large races were run in 1774, and Fredericksburg's October meet was probably the last major prewar event. The future first president of the United States might well have been in the crowd, watching as his friend William Fitzhugh claimed prizes with his entries, Kitty Fisher and Regulus. Washington, along with Fitzhugh, was a member of the Fredericksburg Jockey Club.

George Washington's penchant for racing is well documented in his papers. One of his first tasks as a young surveyor was to lay out what would be one of his favorite tracks at Alexandria, Virginia.

A RANGER FOR GENERAL WASHINGTON

It was while he was leading his forces in the New York campaign that General Washington noticed the excellent horses being ridden by the Connecticut Rangers. They were a handsome gray and enough alike to cause the Virginia commander to enquire as to their origin, as he was particularly fond of white (gray) horses. He dispatched his friend and sub-commander "Light Horse Harry" Lee to reconnoiter.

Lee discovered that all of those horses shared a sire, a gray Oriental stallion called Ranger. This horse's history reads like an adventure tale. According

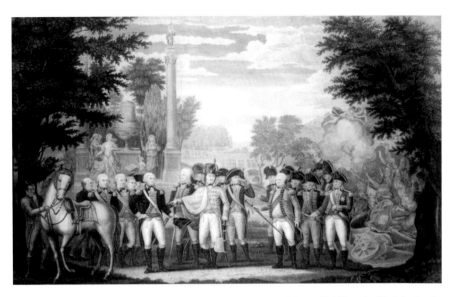

The British surrendering their arms to Gen. Washington after their defeat at York Town in Virginia October 1781, by John Francis Renault. *Courtesy of the Library of Congress.*

to Hervey, he had first been given by the sultan of Morocco to a British sea captain. Before returning home, the captain's ship paid a call to the West Indies. The stallion was let ashore for exercise. There he hurt himself so badly that the captain abandoned him as a useless cripple and set sail for England.

A merchant from Connecticut found him there, put him in slings and nursed him back to some semblance of health. Ranger was shipped to Hartford in 1766, where, although his maimed limbs never did completely recover, he was able to stand at stud in the Provisions State until his get caught General Washington's eye.

Washington made quick use of this newfound intelligence. He sent Captain Lindsey of Port Royal, Virginia, to the farm at Windham, Connecticut, where he negotiated for the horse. After an exchange of 125 hogsheads of tobacco (equivalent to 605 guineas, or $3,000), the castaway was Virginia bound and had a new name, Lindsey's Arabian. He stayed at Lindsey's Mill in 1799, later passing in ownership to a Marylander, but the gray horse died on Virginia soil at Alexandria in 1785 at the age of twenty-three.

Perhaps his most famous colt was George Washington's own Magnolia, or Magnolio, as the general often spelled it. He was foaled at Mount Vernon on June 5, 1780. Unlike most of Ranger's get, Magnolio was a chestnut and his dam was an Othello mare from the famed Selima line.

In one of his races, remembered by Thomas Peter forty years after the event, Magnolio was bested by a horse belonging to Thomas Jefferson at the Alexandria track. This was, Hervey concludes, the only instance in which two presidents faced each other as contenders on a racecourse. Magnolio stood at Mount Vernon from 1785 to 1788 before being sold to Light Horse Harry Lee for five thousand acres of good Kentucky land.

George Washington, like his fellow Virginian Thomas Jefferson, was an excellent horseman and was described by Jefferson as being the best rider of his day, "the most graceful figure that could be seen on horseback." Washington's wartime favorite was a chestnut hunter named Nelson, a gift from the governor of Virginia, Thomas Nelson Jr.

The general ever had an eye for excellent horseflesh, regardless of the circumstances. In a letter to François Joseph Paul, Comte de Grasse, dated November 5, 1781, he wrote:

> *The Chevalier De Mollevrier is so good as to take charge of two horses, with their provision of forage. I flattered myself with the hope of sending Your Excellency two of a much more conspicuous figure; but I have been exceedingly disappointed.*
>
> *The Enemy in their ravages of this Country which was celebrated for its race of horses, did not spare that useful accessary in war; and it has been impossible to recover such as I should have wished to present to Your Excellency. Such as these are I entreat you my dear General to accept them, and my excuse for their not being equal to my wishes.*

JACK JOUETT: VIRGINIA'S PAUL REVERE

Although but a single Revolutionary battle was fought in the Albemarle County area, one fast horse and his daring rider were to play a critical role in the war. In early summer of 1781, the Virginia legislature found itself in Charlottesville, having escaped the British invaders at Williamsburg and later Richmond. Forty members of the legislature—including Governor Thomas Jefferson, Richard Henry Lee, Thomas Nelson Jr., Benjamin Harrison and Patrick Henry—came to Charlottesville, with Jefferson staying at his grand home, Monticello.

None of these Patriots was aware that British commander Cornwallis had sent the infamous Colonel Banastre Tarleton with 180 dragoons and 70 mounted infantry to capture them. As it happened, Tarleton had given his many men a rest at the Cuckoo Tavern from 11:00 p.m. to 2:00 a.m. on June 3. Jack Jouett overheard Tarleton's plans and, in typical American fashion, took the initiative to hightail it to Charlottesville to give the legislators warning.

Jack, himself a tavern keeper's son, was no aristocrat, as were the men he was determined to save, but he certainly did count himself as an American. Indeed, he and his father had signed the Albemarle Declaration, renouncing King George III, and he would also serve as a captain in the Virginia militia.

The story goes that the night was a dark one—Jack had no moon for a guiding light, unlike Paul Revere. His path was not a public road, either. At a dead gallop on a black hunter called Sallie, he took what was probably an old Indian trail, long overgrown with briers and brush, heading to Charlottesville. Approximately forty miles of this grueling, ground-pounding pace gave him scars he bore the rest of his life.

Captain Jouett's race against time ran through the night. About 4:30 a.m., Jouett arrived at Monticello, where Jefferson gave him a refreshing glass of Madeira. Jouett rode on to Charlottesville, to his father's Swan Tavern, to warn the rest of the legislators. Most of them made their escape over the mountain to Staunton, although seven were captured.

Jack's heroics for the day were not quite finished. General Edward Stevens, grievously wounded at the Battle of Guilford Courthouse, was unable to ride fast enough to outpace the British cavalry. However, the soldiers paid little attention to Stevens. Instead, they vainly chased the handsomely dressed rider who they thought must be a high-ranking officer. The six-foot, four-inch muscular Jouett did enjoy wearing fancy uniforms, in this case a scarlet coat and a plumed hat. They pursued him on a cross-country chase, completely ignoring the more plainly dressed wounded warrior next to him.

On June 15, 1781, the grateful legislature, now safe in Staunton, voted to give Jack a set of pistols and a fine sword as a reward. The next year, Jouett moved to that part of Virginia now known as Kentucky. There he married and settled in Mercer County, where he became known for breeding livestock, including horses, importing much of it from England. Some credit him with helping to establish Kentucky as a horse breeding center. In time he, too, would become a legislator as well as a wealthy farmer.

Although Jouett rode out to the Kentucky lands, local Virginians never forgot their hero. This is the last verse of a poem that appeared in the *Charlottesville Daily Progress* on October 26, 1909, to commemorate Jouett's ride:

> *Here goes to thee, Jack Jouett!*
> *Lord keep thy memory green;*
> *You made the greatest ride, sir,*
> *That ever yet was seen.*

THAT TARLETON TEMPER

There were other famous Washingtons in the Revolutionary War, and one of them bested the English raider Tarleton both on the field and in the drawing room. Colonel William Washington, whom George Washington called "my kinsman," was a Stafford County native. He had been educated for the church, but did better with politics and a military career. He also shared the family interest in fine horses.

He served his country brilliantly as a cavalry leader and was nicknamed "the sword of his country" and "the modern Marcellus," after Marcus Claudius Marcellus, a Roman general in the Second Punic War who conquered Syracuse. Colonel Washington fought at Trenton, Tappan and Princeton under another Virginian, General Hugh Mercer.

When the fighting came to North Carolina, Washington was there—facing off against Colonel Banastre Tarleton. According to John Hervey, Tarleton, while sharing the company of polite Halifax society, mentioned that William Washington was no more than "an illiterate fellow hardly able to write his name." Mrs. Jones, wife of a well-known horseman, replied, "Ah, Colonel, you should know better as you bear upon your person proof that he well knows how to make his mark!" She was referring to Washington's saber thrust at the Battle of Cowpens, which had severed one of Tarleton's fingers.

Not leaving well enough alone, Tarleton turned his unwanted attention to Mrs. Jones's sister, Mrs. Ashe: "I would be happy to see Colonel Washington." She replied tartly, "If you had looked behind you at Cowpens you would have had that pleasure!" Insulted by the implication of cowardice, Tarleton put his hand upon the hilt of his sword threateningly and had to be restrained by his superior officer.

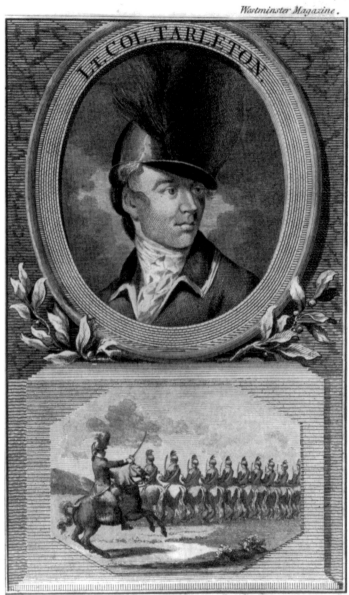

Lieutenant Colonel Tarleton. *Courtesy of the Library of Congress.*

Colonel Washington survived the war and was free to return to peacetime pursuits, including racehorses. At one time, William Washington owned a son of Shark, called Young Shark, who was considered one of the best horses of his day. After the war, Washington married a South Carolina belle and moved to her home state, where he continued to breed racehorses at his Sandy Hill Plantation, about twenty-eight miles from Charleston.

A BYRD FLIES NO MORE

One casualty of war and a life of license was William Byrd III of Westover. After Tryal's defeat at the hooves of Selima, Byrd stopped racing horses in major stakes and concentrated on importing and breeding them. His public life went well enough up until the time of the Revolution. But his finances took a downward spin when tobacco prices fell in the 1760s. And as to personal affairs, well, he had them. In 1756, he deserted his wife, with whom he had five children. As the story went, his wife, convinced that his chest of drawers contained letters that would prove his adultery, scaled the imposing piece of furniture, which fell over, crushing her to death.

Byrd went on to marry again and father ten more children. His finances were complicated by his estrangement from his immediate family, who had lost respect for him. When sides were chosen during the Revolution, he might have risen again in the estimation of his peers, for he had served as a military commander in the French and Indian War. But when the debates raged, Byrd clung to the side of the moderates. Deeply in debt, shunned by his former friends and associates, William Byrd of Westover shot himself to death on New Years Day of 1777.

After his death the war came to Westover. Both British Commanders Benedict Arnold and Cornwallis visited. The second Mrs. Byrd's many Tory connections were so suspect that her personal papers were seized by Virginia officers. At the war's end, the Marquis de Chastellux, who aided the Americans at the siege of Yorktown, remarked that nearby Westover plantation was the most beautiful place in America.

But in a few years, it would no longer be the Byrds' estate. Mrs. Byrd sold off the silver and fine books, and after her death, Westover was sold to the Selden family. However, legend has it that at least one Byrd still resides at Westover. Evelyn Byrd was William Byrd III's eldest half sister. She was

so lovely that when presented to the English king, he remarked that he was pleased that his colonies could supply him with such "beautiful Byrds."

Evelyn was wooed by the Earl of Peterborough, but her father would not give his permission for them to marry. He rushed her back to Virginia, where she died a spinster at only twenty-seven, reportedly of a broken heart. According to tradition, evening visitors at Westover may still hear "the tap of her high-heeled slippers and the swish of her silken gown" on the broad staircase.

RACING BLOOD SHED FOR FREEDOM

When Virginia gentlemen went to war, they saddled the best from their own stables. Fearnought's colts were favorites of Revolutionary War officers. Their size, speed and heart to race eight, twelve or sixteen miles in a day's meet was put to a different kind of test under cannon and musket fire. As an example, Colonel John Hoskins of Mount Pleasant gifted his brother Robert with a fine horse named Sorrell. Robert, mounted on Sorrell, rode off to join the Continental army in Williamsburg in 1776. And Light Horse Harry Lee's cavalry was able to ride to the aid of General Greene so swiftly and surely because of the endurance and speed of his company's blooded horses.

Prime horses were led off into battle not only by their owners but also by looters, as was the case at Bollingbrook in Petersburg. Naturally, breeding operations suffered, and many studbooks from the period simply stop dead with their last entries in the early 1770s. Older stallions, such as John Tayloe's nineteen-year-old Yorick, were sold or otherwise moved to Southside Virginia, where they could escape the looting bands of Loyalist troops who were eager to replace their own fallen mounts. In all, it was estimated that Virginia suffered $15 million in property damage. Many of the Old Dominion's mansions and stables were put to the torch. Some horses were taken without any knowledge of their names or pedigrees and were renamed, raced and possibly bred without understanding their bloodlines.

In 1780, the capital of Virginia was moved from Williamsburg to Richmond, and racing followed suit. The first postwar meets were held at Richmond in 1785, and its first jockey club meetings were held in the fall of the same year. With so much of the bloodstock shifted to Southside Virginia

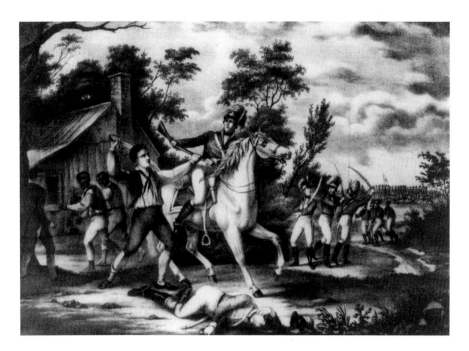

Peter Francisco's gallant action with nine of Tarleton's cavalry in sight of a troop of four hundred men. Artist unknown. *Courtesy of the Library of Congress.*

and North Carolina in advance of the pillaging armies, it naturally followed that after the Revolution the focus for horse breeding would trail to the southern part of the state. The Tidewater region lost the monopoly on the racing scene that it had enjoyed through the colonial period.

The Great Studs——and Mares

Dozens of horses and mares were imported to America in the 1700s, and soon many of their native-born offspring were put to stud by hopeful owners. But time has shown that only a handful of these can be called truly great. Comprehensive books such as Fairfax Harrison's *The Equine F.F.V.'s* give very detailed lists of these horses, which should certainly be consulted for thoroughness. But in this chapter, we look at a few of these early Virginia foundation stallions and mares. They should be remembered, for their blood flows in the veins of so many of today's greatest racers.

SELIMA, A MARE MOST ROYAL

This daughter of the Godolphin Arabian and Shireborn, one of Queen Anne's own mares, was born on April 30, 1745, at the Earl of Godolphin's stud near New Market. In 1750, she was bought by Colonel Benjamin Tasker Jr. and shipped to Maryland, there to be the jewel of his Belair stable.

Selima ran her first American race in Annapolis, Maryland, in May of 1752. She won and was soon after sent 150 miles away for an encounter at Gloucester, Virginia, with William Byrd III's Tryal and several other racers. The Maryland versus Virginia rivalry was a hot one, and Selima's defeat of the champion Tryal was overwhelming.

Virginians thought it a cheat that an unknown import could so thoroughly best them and so for a while thereafter "imports" were banned from Virginia

tracks. They took it a step further and banned *all* Maryland horses from competing in their colony. Marylanders got around this rule by shipping their mares that were in foal to Virginia for delivery, thus qualifying them to race as technically being Virginia born.

Selima retired soon after her famous race. She went on to become a great brood mare, producing champions for both Tasker and Tayloe, who bought her after Tasker's death and brought her to his home, Mount Airy, in Richmond County, Virginia. She was bred only to stallions that had also been imported from England, presumably to maintain the quality of her get. Three of her sons, all by Morton's Traveller, were to prove her worth as the dam of winners: Ariel, Tayloe's Bellair and Lightfoot's Partner. Another of her descendants was Magnolia, or Magnolio, owned by George Washington.

The great Lexington was her descendant, as were many other grand Thoroughbreds. The name Selima was a watchword to prove quality in Thoroughbred ancestry. Her legacy was so pronounced that in 1926, Laurel Race Course named an important race for her: the Selima Stakes.

Another noteworthy import was Mary Gray. This mare, sired by Roundhead, was imported in 1746 by Carter Braxton of King William County. She mated with favorite sire Jolly Roger seven times to produce fillies of remarkable quality who carried their special abilities into the next generations.

FEARNOUGHT: THE PATRIOTS' CHOICE

Fearnought, also spelled Fearnaught, was imported to Virginia in 1764 by John Baylor of Caroline County as a nine-year-old. Mr. Baylor spent years looking for just the right horse and his contemporaries seemed to agree that he found it in this stallion. He had hired an agent to see about finding "a most beautiful strong bay at least 14.3 high, as much higher as possible, provided he has beauty, strength and spi't with it, and one that won some Kings plates with a pedigree at full length and cert. of age under a nobleman's hand as most of the list belong to noble'n."

His agent sent back a list of twenty possible horses. Fearnought was number nine on the list. He stood fifteen hands, three inches and subsequently passed on his size, strength and speed to his descendants. As William H.P. Robertson notes in *The History of Thoroughbred Racing in America*, the colts were immensely

popular with the Virginia Patriots, and many were lost to the guns of the Revolution. However, Fearnought can be found, through the mares, in the pedigrees of many great race horses. After his owner's death, the bright bay was sold and sent south of the James River, the location of many fine horse breeding operations. But he only stood as a sire there for three seasons before dying at the age of twenty-one.

One of his last foals was his best. Syme's Wildair was foaled in the year of the new country's birth, 1776. His owner, John Syme, was a half brother to Patrick Henry and was known as the "homeliest man in Virginia." When captured by the notorious British commander Banastre Tarleton on a raid through Charlottesville, he was rousted out of bed clad in his nightshirt. Tarleton took one look at the ungainly gentleman and declared in a theatrical tone, "Be thou a spirit of health or a goblin damned?" Whatever his appearance, Syme's contribution to the Virginia bloodstock was certainly of a celestial nature. His Wildair did much to rebuild the bloodlines so diminished by war.

Not all the Wildair's stock was used for racing. In 1801, Thomas Jefferson purchased a probable Syme's Wildair descendant, named Jefferson's Wildair, from John Hoomes of Bowling Green in Caroline County for $300. Standing tall at sixteen hands, the seven-year-old bay was not particularly beautiful to behold, but he was an excellent saddle horse.

A Medley Most Elegant

A little, gray horse born in 1776 would make a great name for himself in the new nation that shared his birth year. Medley was bred by Lord Grosvenor and imported from England to Virginia in 1784. He was brought into Virginia by the company Hart & McDonald of Louisa County. Having won some races in England, he was bought through the famous dealer Tattersall for about $500. Although standing no more than fifteen hands high, he sired some of the best racers of his day.

He was sold to James Wilkerson of Southampton County for 100,000 pounds of inspected tobacco. His foals were known for their elegance and many of them shared their sire's beautiful gray coat. John Tayloe III (1771–1828) of Mount Airy called him "one of the most wonderful horses I ever saw," and added, "His stock is decidedly the best we have had. His colts were

the best racers of their day, although they were generally small; but their limbs were remarkably fine, and they were distinguished for their ability to carry weight."

Tayloe, considered one of the most important horsemen in America after the Revolution, owned several Medley colts, including Bellair, Calypso, Grey Diamond and Quicksilver. His horse Lamplighter, a son of Medley, won the first race run at the Washington, D.C. track in 1798. That was a purse of five hundred guineas run in heats of four miles each, a match race against General Charles Ridgely's Cincinnatus.

One of Medley's finest sons was Tayloe's Bellair. The bloodlines of Fearnought, Partner, Mark Anthony, Morton's Traveller and Tasker's imported Selima combined in this fine stallion, only beaten once. John Tayloe turned down an offer of $10,000 for Bellair in 1791, and his descendants are many.

John Randolph of Roanoke also had a Medley colt, called either Randolph's Roan or Randolph's Gimcrack. Medley stood for eight seasons until his death in 1792 at the age of sixteen. His most famous descendants were probably Domino and Hanover, in whose pedigrees he appears several times over. It also seems probable that the white horse that Thomas Jefferson rode to his inauguration was a Medley colt.

SHARK: THE FILLY SIRE

London's Tattersall's auctioned a brown stallion named Shark to Benjamin Hyde of Fredericksburg, Virginia. He brought the proven racer to these shores in September 1786, along with four other horses, with the idea to resell them.

A leading money winner for his time, Shark counted 16,057 guineas in cash, eleven hogsheads of claret and valuable trophies amongst his English winnings. He could run well at four-mile heats, but he also could deliver blazing speed. Foaled in 1771, Shark was fifteen years old when England let go of him. Why was such an amazing animal released to the American Rebels? Like Diomed later on, Shark was considered a failure as a stud in England. With his early foals such a disappointment, why not let the Yanks have him?

Shark had been bred by Charles Piggott of the English Jockey Club. A man of rakish reputation, his nicknames included "Louse," "Black Piggott" and "Shark," a name that he shared with what was for a time his prized

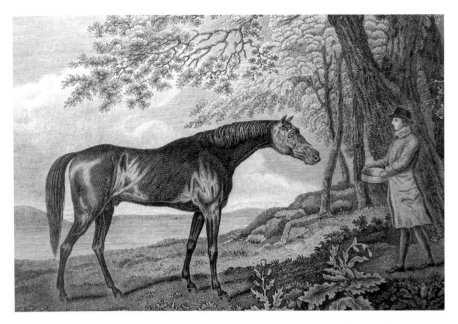

Shark, Imported, from a painting by G. Stubbs. *From* The American Turf Register, Sportsman's Herald and General Stud Book.

possession. When prize-winning Shark finally broke down while running, Piggott sold him to be used as a stud.

Benjamin Hyde sold him locally to Alexander Spotswood, a descendant of Royal Governor Alexander Spotswood. He kept him at his Nottingham plantation in Spotsylvania County for six seasons. Then Shark, too, traveled to spend his last years in Southside Virginia. He was known as a "filly sire" and among his best were Virago, Annette and the elder Black Maria. Shark was strongly built but not beautiful like the gray Medley, and his descendants favored him in looks and abilities.

Later on, Colonel William Washington, the "kinsman" to George and gadfly to Tarleton, was to own a very fine descendant of Shark, also called Shark, which he raced with great success in his adopted home of Charleston, South Carolina.

Diomed: The First Derby Winner

The lords Piggott, Derby (pronounced Darby) and Bunbury were close friends in the licentious days of Georgian England. They sported, wenched

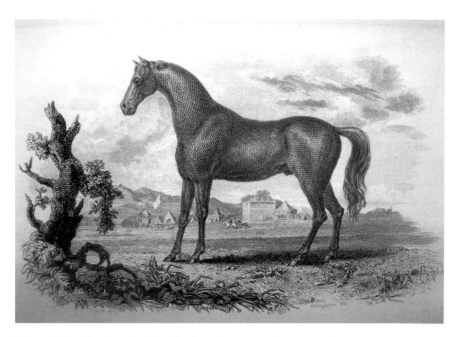

Diomed. *From* The American Turf Register, Sportsman's Herald and General Stud Book.

and gambled, as many rakes of the period were fond of doing, but their particular love was the turf. They wanted to create a race for their own amusement and that of their fashionable friends to be named after either Derby or Bunbury. A coin toss decided the matter and the Epsom Derby was born. Its first run came in 1780, and it was won by Bunbury's horse, Diomed. A chestnut standing 15.3 hands, he would go on to win ten races in succession.

In 1799, at the advanced age of twenty-one (horses live to about thirty), Diomed, too, was sold to the Virginians for a bargain price of $250. Colonel John Hoomes, a leading figure of the Virginia turf scene, imported the elderly stallion in 1799 to live at his farm in Caroline County. Colonel Hoomes and his friend, John Tayloe III, ignored the advice of the English agent who managed the sale of the stallion. James Weatherby declared Diomed a "tried and true bad foal-getter" and recommended that he not be used for stud. Seldom have such dark words proved so undeservedly pessimistic in the realm of Thoroughbred breeding.

Diomed's first crop of American foals was certainly redeeming. During the 1804–05 season, his daughter Madeira galloped home a winner at the

Wine Stakes on the Fairfield Course near Richmond. Another daughter, Diomeda, was also a winner at Fairfield. Top Gallant and Peace-maker also won on their courses. Some other notable offspring were Potomac, Stump-the-Dealer and Duroc.

A foal from Diomed's second year in America, Florizel—later known as Ball's Florizel—proved an undefeated racer and was considered by the contemporary horseman A.J. Davie to be the first top-rank American-bred sire to emerge on this continent. Previously, to get the highest quality, gentlemen would seek out only imported stallions to cover their mares.

Diomed was eventually sold by Hoomes for six times his purchase price. Strong until the end—he died at thirty-one years old—one of his last foals was the famed Haynie's Maria, who bested many of Andrew Jackson's fine horses, to his bedevilment. Thomas Jefferson also liked Diomed. He bred a Chanticleer mare to him to produce a horse named Monticello.

The stallion's legacy as a sire was impressive, and he was called by John Gilmer Speed in his book, *The Horse in America*, "the most important of all horses, so far as race-horses in America are concerned."

Maid of the Oaks

This chestnut mare foaled in 1801 was sired by Colonel Hoomes's import Spread Eagle, winner of the Epsom Derby in 1795. She was out of Annette, who in turn was sired by Shark. Maid of the Oaks was bred by Lewis Willis of Fredericksburg and taken to the races by his son, Byrd. The Willis family had been associated with the town since its beginnings.

After her first disappointing race as a three-year-old (she bolted!), Maid of the Oaks swept the competition in the South. Next she headed north to Washington. At four-mile heats, she bested Ogle's Oscar, Floretta, Sir Solomon, Napoleon and others in fine style. Benjamin Ogle Tayloe, turf historian and descendant of John Tayloe, believed that, all things considered, she was the best performer he had ever seen of either sex.

Her daughter, Young Maid of the Oaks, would be mated with American Eclipse—he of match race fame—to produce the fine horse Medoc, who was himself a leading sire of prizewinners.

SIR ARCHIE

Perhaps Diomed's most lasting influence came from a colt that changed hands many times during his long career. The horse came to be called "the Godolphin of America" for his ability to sire champions. His sons and daughters can be found in the pedigrees of today's leading American racehorses.

In 1799, a ship called *Tyne* arrived in Virginia with six English horses, all for Colonel Tayloe. Castianira was a crop-eared, brown two-year-old. The next year she ran and won—her only victory. Retired to the broodmare band, the still young Castianira was now blind. Diomed had been bought from Colonel Hoomes by Thomas Goode and Miles (J.M.) Selden in 1799. Selden was a thorough horseman, for he managed the racecourse near Richmond called Tree Hill. He also bred and raced his own horses there.

In 1804, Captain Archie Randolph—cousin to John Randolph—and Tayloe brought the blind mare Castianira to Tree Hill. Randolph had her on shares for breeding purposes and his choice for sire was twenty-seven-year-old Diomed. On May 1, 1805, she bore a colt named Robert Burns, for the popular Scottish poet.

Because of his debts, Captain Randolph sold his share in the colt to Ralph Wormeley IV of Rosegill in Middlesex County. Archie Randolph sent the colt to Tayloe's Mount Airy in 1807 with this letter announcing his arrival:

> *I have sent our fine colt for you to take and do with as you please. I am not able to do him that justice such a horse is entitled to. He is thought to be the best colt that is anywhere. Larken says the finest two year old he ever saw. Mr. Wormeley will inform you what are his engagements; any part of which you may take. I have named him Robert Burns under which name he is entered.*

But Tayloe was not inclined to keep him and he traded little Robert Burns to Ralph Wormeley in exchange for a mare named Selima. But first he renamed him Sir Archie, in honor of Captain Randolph. Ralph Wormeley kept him and raced him until 1808, when he posted this startling announcement in the Fredericksburg *Virginia Herald*:

> *Being determined to quit the turf, I offer for sale the following horses which may be purchased with or without their engagements, very low for cash, or*

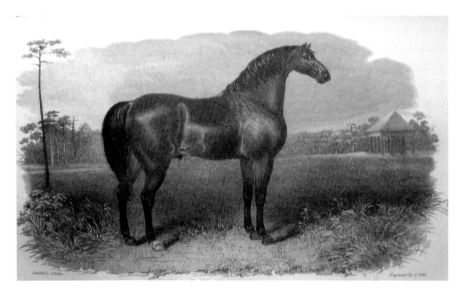

Sir Archie, from a painting by A. Fisher. *From* The American Turf Register, Sportsman's Herald and General Stud Book.

> *on good terms and twelve months' credit… The horses are in good condition*
> *and now training at Prospect Hill where they may be seen and their prices*
> *known by application to Mr. Thomas Larkin or the subscriber.*

Before Sir Archie could be sold, he was run several times, including for the Fairfield Sweepstakes at Richmond. Though the poor colt had barely gotten over a wretched case of equine distemper, he ran gamely. But he could not win. Still, fate was kind to Sir Archie, for his next owner was none other than that "Napoleon of the Turf," William Ransom Johnson. Under his careful training, Sir Archie became the regent of the race field.

His abilities so impressed General William R. Davie of North Carolina that he offered the "Napoleon" $5,000 for him. As his fees equaled $5,000 in one stud season, this proved a bargain. At last he passed to Mr. William Amis of Halifax, North Carolina. Mr. Amis, along with J.J. Harrison of Southside Virginia, created the *American Stud Book* in 1830, picking up on the work of John Randolph, who had become too ill to complete it. Mr. Randolph, despite his gossiping about Sir Archie's origins, thought very well of the horse and sent at least nine of his mares to be bred to him.

Sir Archie died on June 30, 1833, on the same day as his son, Sir Charles, who had been fulfilling his duties at William Ransom Johnson's stud farm in

Chesterfield County. An obituary written in the July 1833 *Turf Register* read: "Peace to their ashes! Theirs was an enviable destiny. How few of us can boast of having so honestly acted well our parts as did these two noble animals."

Sir Archie's blood became the standard among the Thoroughbreds of the 1850s. As Benjamin Ogle Tayloe remarked, "A few years ago the prominent stallions of our country were all of one blood. If a man wished to raise a blood colt what was the fact? Why, he had only to determine whether his mare, she, too, of the Archie stock, should be put to Henry, Sir Charles, or Eclipse!"

Sir Archie's great-grandson, Lexington, though not born in Virginia, carried so much of that amazing speed and stamina that he is remembered as the most influential American sire for generations. Lexington was also a direct descendant of the gallant imported Selima. Sir Archie's direct male line of influence went extinct with Lexington, but Lexington's daughter Aerolite would carry his speed forward through her get into the present day.

Boston—Damn His Eyes!

There was a colt born on a Virginia farm whose temper was so horrid that his first trainer recommended that he be either gelded or shot, preferably the latter. This was Boston, a horse named not for a large city in New England but for the card game in which he was won. Boston was a strapping chestnut colt whose wicked temper and winning ways made him the bane of tracks both North and South.

He was foaled in 1833 in Richmond, Virginia. Bred by the lawyer John Wickham, who had been Aaron Burr's counsel during his trial for treason, he was put up as stakes and lost in a card game to Wickham's friend, Nathaniel Rives. Boston was sired by Timoleon, who was sired by Sir Archie. When he was declared vicious by his first trainer, Boston's manager tried to whip him into submission. To keep him from a favorite activity of throwing his riders, the trainer had him tied down and beaten by stable boys.

Soon after, he was entered into a match race at Richmond where he began well enough, running away with the race and getting a strong lead. In the middle of the action, he stopped dead and refused to move. After this debacle, the proud horse was used as a common riding animal in the streets of Richmond for a year. He bucked, he thrashed, but after a season of this treatment, he was more or less rideable.

The Great Studs—and Mares

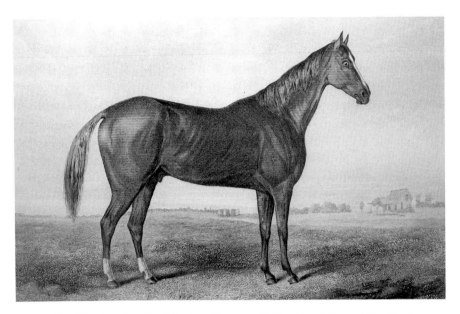

Boston. *From* The American Turf Register, Sportsman's Herald and General Stud Book.

In those days, it was not so unusual for a racing stallion to serve as a stud horse while still earning money on the track the same year. But Boston rather outdid himself. In 1841, he was bred to forty-two mares in the spring while racing five times that fall. His famous match race against the Northern mare Fashion was a highlight of the antebellum years and is discussed further in chapter 8.

Boston went on to win forty of his forty-five starts, racing until he was ten years old. He was possibly the first horse to earn protection money, for his owners were paid hundreds of dollars to keep him away from race meets. This was probably done to make it an even race for the others—with the red horse being such a sure favorite, no one was likely to make money if he put in an appearance; no one, that is, besides Boston's owner. But there was also the matter of temper, which never completely left the horse.

Never a good sport, Boston was known to bite his competitors as they tried to pass him. His reputation grew until he was nicknamed Damn His Eyes. Completely blind, he died of old age on January 31, 1850, but he died as he lived, fighting and kicking in his death throes until his stall was coated in blood. Yet this rebellious stallion left a rich legacy. Born after his death, his son, Lexington, was considered one of the finest sires of the turf. Their descendants include no less capable racers than Man o' War and Secretariat.

Turfmen of Prominence

JOHN RANDOLPH OF ROANOKE

His voice was high-pitched, his temper irascible. He rode "like a monkey" and his devotion to horse racing was extraordinary. In modern times, John Randolph is known as having been a great statesman and orator, but he could also be properly described as a titan of the turf.

Certainly his own bloodlines ran to racing. His ancestor, William Randolph of Turkey Island on the James River, was noted in court records for having served as a starter in a quarter race at Malvern Hills near Richmond in 1689. According to Fairfax Harrison's *Roanoke Stud*, he and his cousin David Meade III of Maycox were constant companions in their youth. They rode from race field to race field along the bridle paths that connected communities. Randolph was known for his unique and oddly modern way of riding—perched up on his horse, with short stirrups. In Henry Adams's account of Randolph's days, he lived in a boy's paradise of indulgence; rode, fished and shot in the Virginia countryside; and had his memory stuffed with the genealogy of every well-bred horse in the state.

John Randolph had a special fondness for quarter horse races, and he had ridden in some excellent ones as a young man. And he persisted, despite prevailing wisdom, to use Janus's descendants to improve his racing stock. In 1799, he began deliberately breeding quarter horses at his home, called Roanoke. This Roanoke was far away from the southwestern Virginia city of

John Randolph of Roanoke, by John Sartain. *Courtesy of the Library of Congress.*

the same name. Randolph's Roanoke was no grand mansion, but rather two frame cottages. One he called his winter house, the other his summer house.

He usually signed himself "John Randolph of Roanoke" to make a clear difference between himself and the many relatives who shared his name. He could not be called a successful breeder, for his Janus-bred stock never competed very well over the longer distances. Yet at the time of his death he owned over 130 horses.

In his last speech, made only a little time before his death, he recalled the race fields of his younger years: Petersburg, Pride's Old Field, Gillesfield and

Ravenscroft. But young Randolph had no hesitation in rambling across state lines to compete at the choicest courses. He cut a remarkable figure and was remembered as a brash teenager who badgered Sir John Nesbit into a match race at Newmarket track in Charleston, South Carolina, in 1796.

This was no grave statesman or modest young country gentleman. The John Randolph who challenged the Scottish baronet was described as a "tall, gawky-looking, flaxen-haired stripling, apparently of the age of from sixteen to eighteen, with a complexion of a good parchment color, beardless chin, and as much assumed self-consequence as any two-footed animal one ever saw."

Nonetheless, the stripling's crouched riding seat, learned on the wild and wooded quarter paths near his home, proved more than a match for the visiting lord. While Randolph rode full out in his "monkey seat," handsome Sir John Nesbit rode with the fashionable, upright elegance of the aristocracy. The brash American won this race and continued to ride as much as he could. Come spring and autumn, he would be found at the many tracks along the James River.

He was at the Petersburg races in May of 1799, before he went to serve in Congress. Come another May race season in 1833, just before his death, John Randolph was back at Petersburg to enjoy the fellowship of the turf. Yet he was never a "betting man." He usually placed small wagers to add a bit of sparkle to the sport, though in truth, he did not care for that part of racing. In 1799, he wrote of the "indignation which I feel at the sight of men who prowl at every public place for plunder, assuming the airs of gentlemen and exchanging familiar salutations with men of honour." Nonetheless, he felt that horse racing was a better pursuit than cards or dice.

When he grew ill and could no longer ride, Randolph's preferred way to travel long distances was in a "chair" pulled by two Thoroughbreds—at racing speed, when the roads permitted. He was so widely regarded as a brilliant horseman that his friends badgered him to compile the first *American Stud Book*. This he could not do, but his expertise on matters equine was so admired that his slightest word was enough to seriously endanger the legacy of one of America's most influential sires. Fairfax Harrison described Randolph as having "an elfin habit of mind." Surely he showed a puckish sense of humor when, during a visit to the Virginia Hot Springs, he spread, or perhaps invented, a bit of gossip about the great Sir Archie.

All that it took was John Randolph of Roanoke's suggestion that Sir Archie was the wrong color (a bay) to be a Diomed colt (usually chestnut) to start the

rumors flying. It seems that Sir Archie's dam had been bred at Randolph's cousin's estate, so he claimed to know that it was not Diomed himself but rather Gabriel, an English racer often used as a teaser stallion, who did the deed. Randolph later denied the story, but it sparked a war between turf writers and breeders who cast a pall on Sir Archie's ancestry, implying that he was very closely related to a cart horse.

John Randolph surely followed his family's motto of "Say What You Think." In Congress, he was a House leader and fearsome debater. He was later appointed to a Senate seat and won it by election shortly thereafter. On his home turf he could certainly argue either side. Despite the fact that Sir Archie was his cousin's (Archie Randolph) namesake, he had no difficulty in either starting the rumor or later trying to quench it by publishing an ad declaring that he had at his farm a stallion named Roanoke, sired by Sir Archie, who was in turn sired by Diomed.

He served as United States minister to Russia—an appointment made by another racing enthusiast, President Andrew Jackson—but his diplomatic ways at home and in Congress were rather more notorious. In 1803, Federalist William Plumer of New Hampshire wrote of him:

> *Mr. Randolph goes to the House booted and spurred, with his whip in hand, in imitation, it is said, of members of the British Parliament. He is a very slight man but of the common stature. At a little distance, he does not appear older than you are; but, upon a nearer approach, you perceive his wrinkles and grey hairs. He is, I believe, about thirty. He is a descendant in the right line from the celebrated Indian Princess, Pocahontas. The Federalists ridicule and affect to despise him; but a despised foe often proves a dangerous enemy. His talents are certainly far above mediocrity. As a popular speaker, he is not inferior to any man in the House. I admire his ingenuity and address; but I dislike his politics.*

His politics focused on states' rights, yet upon his death he freed his slaves and provided money for them to be resettled in another state. One group went to Rumley, in Shelby County, Ohio. He requested that a rough block of stone that he had used for washing up be set over his grave at Roanoke. But he was not allowed to remain there, later being interred with many other famous Virginians in Hollywood Cemetery in Richmond.

WILLIAM RANSOM JOHNSON: "NAPOLEON OF THE TURF"

He was called the Napoleon of the Turf, for he trained and owned the greatest racehorses and mares during Virginia's golden age of racing. At various times he owned Boston, Sir Archie, Sir Charles, Bay Maria and Revenue. He trained dozens of fine horses, including the fillies Flirtilla, Bonnets o' Blue and Reality. He earned his nickname during the 1807–08 season, when he won sixty-one races out of sixty-three.

Although he moved to Virginia and was accepted as a Virginian, William Ransom Johnson was born just across the border in Warrenton, North Carolina. His father, Marmaduke Johnson, is said to have gotten into the racing habit by accident. His carriage driver decided to unhitch a mare from her traces and take her to the races. She won, and Marmaduke Johnson, rather than being upset, decided to take up horse racing in a big way.

His son, William Ransom, took a lively interest also, much to his father's chagrin. Mr. Marmaduke Johnson would have been much happier had his boy decided to go into a regular business. He tried to convince him that more ordinary employment would be a better career choice than training racehorses. Johnson Sr. decided to teach Johnson Jr. a lesson. He challenged his son to a match race, but it was the father who learned the lesson of exactly how good his son was at training racehorses. He turned over management of his stables to the brilliant teenager. But William Ransom Johnson proved capable in other fields than race fields. When he was twenty-five, he served in the North Carolina legislature. His handsome looks and prematurely white mane earned him another nickname with the ladies—"Irish Beauty."

Handsome Colonel Johnson became a proper Virginian when he bought a horse farm in Chesterfield County called Oaklands. His eighteen-room mansion overlooked the Appomattox River and featured a two-mile straightaway of training track just beyond the front lawn. A contemporary wrote that everything about the place showed the master's executive ability and love of order. Colonel Johnson also served in the Virginia legislature. Although he prided himself on never having read a book through, a visitor thought he had a better mind and would have made a better president than General Andrew Jackson, another turfman.

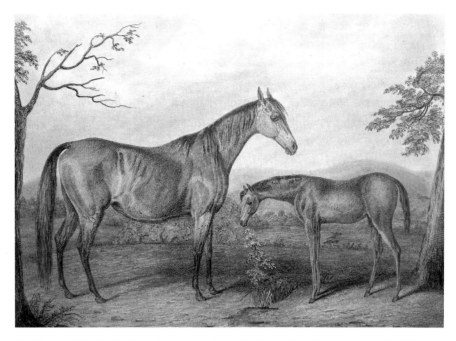

Bay Maria and Her Foal by Priam, from a painting by E. Troye. *From* The American Turf Register, Sportsman's Herald and General Stud Book.

Blooded horses played such a key role in Colonel Johnson's life that over the gate at Oaklands he had these words written: "There is nothing so good for the inside of a man as the outside of a horse."

Colonel Johnson stage managed the greatest North/South match races of the nineteenth century. These exciting affairs drew crowds from hundreds of miles to wager on their favorites. In 1822, he challenged Van Ranst's great American Eclipse, an undefeated eight-year-old, to take on a champion Southern horse of his choosing. He chose a horse named Henry to try for the prize. Untested as the colt was at the four-mile distance, Colonel Johnson must have been pleased when the three-year-old triumphed at four-mile heats at Petersburg, Virginia, setting track records of 7:54 and 7:58. But the colonel missed the entire event. He was sick in bed at his hotel, having been the victim of a plate of oysters—or lobsters and champagne, as he told it. The story was merrily passed along by John Randolph, who declared, "It was not Eclipse, but lobsters that beat Henry."

Colonel Johnson was not finished with his maneuverings. He trained John Bascombe, the Southern horse who beat Post Boy in 1836. John Bascombe's

jockey was a black man named Willis. Willis was the "first rider" for Johnson's stables and rode John Bascombe to victory during a final, grueling heat.

Colonel Johnson's opinion on all matters equine was in tremendous demand. He led the way in establishing jockey clubs and new racetracks. Of character he had aplenty, so much so that his rivals would sometimes turn their horses over to him for training, knowing that he would do right by them. Respected, certainly, and revered would not be too strong words to use to describe him.

According to Robertson, "He was of steel, rather than iron, and could sway a little when necessary. He did not allow his determination to degenerate into pure stubbornness. When another horse defeated one of his, if he considered the race truly run, Johnson often would buy the rival, and it was said he was never more dangerous than in defeat."

He was so well-regarded by his sometime rivals on the turf that two of them—John Randolph and Abner Robinson—each named him as executor of their estates and each willed him $25,000.

John Randolph counted him a particular friend and he gleefully joined the Napoleon in Chesterfield as he prepared for the 1823 match race. According to Hugh A. Garland's biography of Randolph, he hadn't slept so well for ten years and his health was much improved.

As John Randolph remembered it,

> To that night, spent on a shuck mattress in the little garret room at Chesterfield Court-house, Sunday, March the 9th, 1823, I look back with delight. It was a stormy night. The windows clattered, and William R. Johnson got up several times to try to put a stop to the noise, by thrusting a glove between the loose sashes. I heard the noise; I even heard him; but it did not disturb me. I enjoyed a sweet nap of eight hours, during which, he said, he never heard me breathe.

THE TAYLOE FAMILY OF MOUNT AIRY, RICHMOND COUNTY

Mount Airy was designed by John Tayloe II (1721–1779), a third-generation Virginian, to resemble an Italian villa, with both native sandstone and imported English white stone. Mount Airy was the scene of great hospitality. Tayloe's eight daughters married into very prominent families: the Lees,

Mount Airy, Richmond County, Virginia. *Courtesy of the Library of Congress, Historic American Buildings Survey.*

the Carters, the Washingtons, the Berkeleys, the Pages, the Wormeleys, the Lomaxes and the Corbins.

John Tayloe II imported Tayloe's Childers in 1751, a well-made bay who competed in the first Virginia-Maryland intercolonial races. These were held in Gloucester, at Anderson's race grounds, on December 5, 1752. Tayloe's Childers also stood at stud in Stafford County. Other famous equines at Mount Airy were Jenny Cameron, Juniper, Nonpareil, Single Peeper, Traveller and Yorick.

John Tayloe III (1771–1828) was educated at Oxford and Eton and went on to serve in both the Virginia House of Delegates and Senate. He married Anne, the daughter of Maryland Governor Benjamin Ogle. Between 1791 and 1806, John Tayloe III's diary records 113 wins out of 141 starts for his stable. This tally does not include the 1802 season, which was reported to be greatly successful but whose records are lost. Among his winners were Grey Medley, Young Selima and Bellair, and for a very little while he owned the great Sir Archie. Mount Airy still holds portraits of early winners and silver cups won at four-mile heats centuries ago.

Nicholas St. John Baker, an English diplomat, recorded details of his visit to Mount Airy in May of 1827. After breakfasting with a large party, he was left to be entertained by the ladies, as the presence of the gentlemen "was required at the club on the course." Following lunch, he accompanied the

ladies to the racecourse on the estate. While visiting, he enjoyed tea, walks in the park where he saw fine deer and a visit to the portrait gallery. In so many ways, Mount Airy preserved England.

AN UNSEXED LEVIATHAN

Colonel Tayloe liked to win his races, and there is certainly more than one way to win an encounter on the track. In 1798, he had entered a horse named Calypso in the Jockey Club Purse at Hanover Courthouse. The race was to be run in four-mile heats, and there was much talk of an entry named Leviathan. Leviathan, a gray bred by Dr. Turpin of Goochland County, Virginia, was five years old and could be bought. And so he was.

Colonel Tayloe purchased him for $1,125 and promptly withdrew him from the race. Calypso came in the easy victor. Leviathan ran the next day in a two-mile event, which he won with no difficulty. He went on to win twenty-three consecutive starts and campaigned at Annapolis, Richmond, Petersburg, Tappahannock, Fairfield and Alexandria, among others.

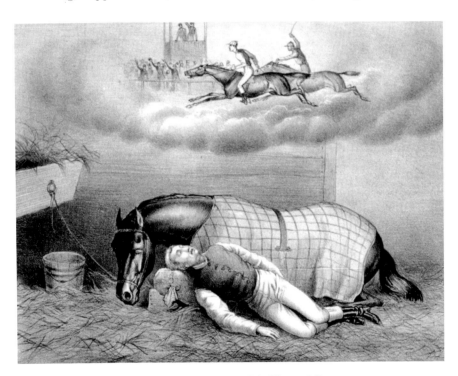

The Jockey's Dream, 1880. Currier & Ives. *Courtesy of the Library of Congress.*

The sixteen-plus-hand gelding was finally beaten at Fredericksburg on October 24, 1801. By then an eight-year-old, he was put up against Colonel Hoomes's four-year-old filly Ariadne, who was also known as Fairy. According to Hervey, the contest did not go well for the gelding: "The race was very close throughout, the two being scarcely separated and considerable expectation entertained to the last that Leviathan would win; but in the second heat Dick's stirrup leather broke. 'It was clear that Leviathan had lost his spirits, for without a whip and spur he could not be made to run.'"

Hervey believed that Leviathan's depressed spirit was likely due to a strenuous match race that he had run that spring. Put up against Colonel Tomlin's gelding Brimmer, it might have been an easy gallop for Leviathan had he not been carrying 180 pounds to Brimmer's 110. Even so, the geldings ran neck and neck, and Brimmer broke down when it was through.

Long-striding Leviathan was utterly exhausted and could not be run until the fall. Then he won at Richmond, but it was his last win. The next encounter would be the ill-fated run against Fairy. He never quite recovered, but Colonel Tayloe placed him first among the "cracks" he owned, and he was considered by some the finest horse of his time. One turfman reported decades later that "in an eminent degree he united speed, bottom, strength and toughness."

His fame eventually spread across the Atlantic. A "plain Virginia farmer" writing for Britain's *Sporting Magazine* in the 1805 April–September issue gives us this account:

> *Colonel Taylor's* [sic] *grey gelding Leviathan, was matched against Major Hoskins's Wildair, a single five mile for 200gs. Leviathan carrying 180 pounds to Wildair's 110 pounds. The bets were ten to one in favour of Wildair, in consequence of the extraordinary weight Leviathan had to carry; notwithstanding which, after a severe contest for four miles and a half, he headed his opponent, and won his race by a head; running the five miles, with this wonderful weight, in eleven minutes precisely, which, I trust you will agree with me, is worthy of a place in your amusing and valuable publication. This valuable horse broke down in running for some of our plates, many of which he won, and is now used as a trooper, or more properly a charger.*

COLONEL JOHN HOOMES: A LEGENDARY HORSEMAN

As a leading importer of quality horses, John Hoomes (1749–1805) was much responsible for Caroline County's designation as "the cradle of American racing." When the celebrated winner of the first Epsom Derby was sold to Hoomes in 1798, Diomed was an aged twenty-one-year-old. A bargain at $250, he entered stud service immediately and went on to raise the level of racing stock throughout the Old Dominion. Hoomes sold him soon after for six times his purchase price.

He also imported the Epsom Derby winner, Spread Eagle. A prolific sire, Spread Eagle covered 234 mares in 1801. Another success was the racer Dare Devil, who in 1802 won at Petersburg, New Brunswick, Hicks Ford, Warrenton, North Carolina, and "many other places." Dare Devil was foaled in 1787 and descended from all three Thoroughbred foundation sires: the Godolphin Arabian, the Darley Arabian and the Byerley Turk. Hoomes's other noteworthy imports included Bedford, Stirling and Speculator.

Besides importing and raising some of the best horses in the country, the colonel also ran a racing stable. Before the American Revolution, he bought a filly named Sally Wright from his friend John Tayloe II. After her race days were done, Colonel Hoomes made her the basis of his breeding operation.

In the years after the Revolution, he did what he could to revive interest in Virginia horse racing, forming the Virginia Jockey Club in 1788. His newspaper advertisement that year ran thusly:

> There will be several Days Racing, and there is no doubt but that they will be equal to any ever run in this Country, as many of the first Horses are now in training for them, and the best rules will be strictly observed. Great Attention will be paid to accommodate ladies and gentlemen that come a distance, for which Purpose many of the best Houses in the Neighborhood will be opened, that are very convenient to the Race-Ground.

Those races were run at Colonel Hoomes's own racetrack in Caroline County. The following year, the public was notified that accommodations for gentlemen had been greatly increased. Further "a Ball and genteel supper" would be held every night of the meeting, with tickets costing one dollar

each. It was a lively time for ladies and gentlemen weary of war and ready to reclaim their social sphere.

Among Colonel Hoomes's friends was the acerbic horseman John Randolph. Hoomes persuaded him to take on one of his newly imported stallions at his Roanoke stable, Hylton's King Herod. Colonel Hoomes's customers for his bloodstock included Thomas Jefferson and James Madison.

It is said that Colonel Hoomes's home is the longest continuously occupied residence in Virginia. The house, dating to 1742, was built on a three-thousand-acre land grant made to Major Thomas Hoomes in 1667. He called the farm Bowling Green after a family home, Bolling Green, in England. Later the town took on the name, and the estate was called Old Mansion for many years. The estate has been appropriately renamed Bowling Green Farm by its recent owners.

A ghostly legend has attached itself to Colonel Hoomes's memory. Naturally it involves horses. From his dining room, Colonel Hoomes could look out upon the racetrack. As so often happened in those days, several of his children died in early childhood. Each time, day or night, he would hear ghostly hoofbeats to herald the death of another family member. No horses were visible, but the sounds were distinct. About the time of his fiftieth birthday, he heard the dreaded thunder of hooves once more. He sprang to the window and saw only the deserted racetrack. "Another death!" he cried with a shudder. Before another day had passed, he would breathe his last.

JOHN BAYLOR OF NEW MARKET, CAROLINE COUNTY

John Baylor (1705–1772) was the heir of a Tidewater dynasty. He was educated in England, having studied at Cambridge, and there he also absorbed an interest in racehorses. In 1726, he took a patent on a large tract of land in Caroline County. He built a sizeable house, which unfortunately no longer stands, although there is an 1853 house on the property. He named his estate after Newmarket, the well-known racetrack located near his English alma mater. John Baylor was probably the leading importer and breeder of English racers to the colonies before the Revolution.

He brought over Mr. Routh's Crab in 1746. Perhaps most significantly, he imported the nine-year-old Fearnought in 1764. Fearnought is discussed at length in chapter 5. Baylor's ties to other prominent gentlemen of the turf

are evidenced by how very many excellent horses were bred at his stables. William Fitzhugh's Regulus was a son of Fearnought, and Baylor also sold Fitzhugh a horse named Gallant.

FRANCIS THORNTON OF SOCIETY HILL

Francis Thornton (circa 1725–1784) was part of a well-known Caroline County family. He married Sarah Fitzhugh, and they lived at the Society Hill estate in what is now King George County. He had great knowledge of horses' pedigrees and was regarded as a prominent Virginia horseman. Readers of turf history will find that he had a gray, native-born mare in the famous Selima race, where she raced with others owned by John Tayloe II and William Byrd III. Colonel Thornton was also the last owner of Childers.

Society Hill stood as an example of a beautiful, early American house for many years until it became at last so dilapidated that it was dismantled, and its handmade bricks were used to build a wall at Mount Vernon.

THE LEES OF STRATFORD HALL, WESTMORELAND COUNTY

Visitors to Stratford Hall, the birthplace of Confederate commander Robert Edward Lee, will see sundry reminders of the family's ties to the racing scene. The barn is there, and pastures, too. In the Great House is a large period portrait of the Byerley Turk. Impressive as Stratford Hall is today, it has known hard days. By the time of young Robert's birth in 1807, the family fortune had been woefully expended by his father, Light Horse Harry Lee of Revolutionary War fame. Light Horse Harry proved his love of the turf by buying George Washington's racing stud Magnolio for many acres of good Kentucky land.

In 1766, Colonel Philip Ludwell Lee imported a gray stallion named Dotterel. He was a descendant of the Godolphin Arabian and was widely believed to be a swift racer. He stood at Stratford Hall for ten years. Although little is known of the speed of his progeny, Major General B.F. Cheatham believed it likely that he was used to improve hunters and general riding horses.

"Light Horse" Harry Lee. *Courtesy of Stratford Hall.*

Colonel Lee enjoyed entertaining at Stratford as well as visiting his many friends. He was ever at the ready for a jaunt to the next neighborhood, as the family chronicler Charles Carter Lee recalled:

> *Colonel Phil…was fond of visiting & receiving his friends, & took such sudden frieks* [sic] *to visit them, that his wife always kept a trunk ready packed with such clothes as he required to carry with him on such excursions so that it could be put in his coach…as soon as it was ready; when taking with him some of the performers on the wind instruments of his band, they would soon announce his approach to the residents of Sabine Hall, Mount Airy, Menokin (his brother Francis Lightfoot Lee's home) or Lee Hall, or even more distant friends.*

The Lees bred Mark Anthony, the dark brown racer who was called by Charles E. Trevathan in his book, *The American Thoroughbred*, "the rival and successor of Janus in the southern part of Virginia, and along the northern border of North Carolina." Mark Anthony was sired by Partner and his grandmother was the famed import Selima. He might have been well-bred, but he had a horrid habit of rearing on his hind legs at the starting post and "screaming" until the other horses got off, according to James Douglas Anderson's *Making the American Thoroughbred*.

One of his best-known colts was Comet, who beat Colonel Washington's Ranger at four-mile heats over Charleston, South Carolina's Newmarket course in 1788. Comet was no more than 14.2 hands high and black, with a blaze on his face, white-rimmed eyes and four white stockings. The Ranger he bested was a descendant of the castaway Arabian stallion of the same name.

RALPH WORMELEY OF ROSEGILL, MIDDLESEX COUNTY

The Wormeley family came from Yorkshire, England, where their estate was known as Hatfield. In the seveteenth century, they arrived in Virginia, settling first in York County. Immigrants Christopher and Ralph became members of the governor's Council of State, which has been called the "Virginia House of Lords."

In 1649, Ralph Wormeley patented a tract of land, establishing his home Rosegill in 1651 on the banks of the Rappahannock near Urbanna. His son,

also named Ralph (1650–1700), sailed to England to attend Oxford. He returned to Virginia, where he held many political offices. He was considered by one of his contemporaries to be "the most powerful man in Virginia."

Succeeding generations of Wormeley patriarchs, also named Ralph, continued to live at Rosegill for many years. They were active sportsmen and may best be known for importing Jolly Roger in 1750. Jolly Roger was considered the first distinguished stud horse in Virginia. He was first sent to stud in the Rappahannock Valley and later moved to Southside Virginia.

The Wormeleys were not among the founding Patriots of the country. Having served for many years in the House of Burgesses, they sympathized with Britain and were found out. In 1776, when tempers were running hot, a letter written by young Mr. Wormeley was intercepted. In it, the Eton graduate showed his loyalties in plain terms. He was summoned before the Virginia Convention. They required him to post a bond of £20,000 and confined him to his father's estate in Berkeley County (now West Virginia), far away from river traffic, for two years. When he returned to Rosegill, the war was still on and a British privateer sailed in and ransacked his estate.

After the war, the Wormeleys reconciled to the new government. In fact, the fifth Ralph Wormeley (1744–1806) served in the House of Delegates several times. Rosegill passed out of the Wormeley family's hands shortly after his death.

MANN PAGE OF ROSEWELL, GLOUCESTER COUNTY

Mann Page I (1691–1730) built what was the greatest private home in Virginia in 1725. Rosewell was situated on the banks of the York River. It was made of brick and contained thirty-five rooms, including a great hall paneled with polished mahogany. Its grand stairway could allow eight people to pass, and the mahogany balustrade was carved to resemble baskets of fruits and flowers.

Mann Page died within five years of its completion. Bishop Meade wrote that his early death was God's punishment for spending so lavishly. Page's first wife was Judith Wormeley (1694–1716), a daughter of Ralph Wormeley of Rosegill. On her tomb was inscribed in Latin, "As a most excellent and choice lady…a most affectionate wife, the best of mothers and an upright mistress of her family, in whom the utmost gentleness was united with the most graceful suavity of manners and conversation."

Rosewell, Gloucester County, Virginia. *Courtesy of the Library of Congress, Historic American Buildings Survey.*

His second wife was also named Judith. She was the daughter of Robert "King" Carter. Their son, Mann Page II (1718–1788), was Rosewell's heir. He married twice, and the son of his first marriage, John Page (1744–1808), was a scholar, Revolutionary Patriot, member of Congress and governor of Virginia. He was a lifelong friend of Thomas Jefferson, who had been a fellow student at William and Mary. It has been said that Jefferson drafted the Declaration of Independence in the cupola at Rosewell, after long talks with his host.

When not actively engaged in politics, the Page family could often be found on the race field, sending their horses against William Fitzhugh, Alexander Spotswood and other leading lights of the Virginia racing scene.

Rosewell was sold out of the family in 1838. Its next owners stripped it of all its beauty, chopping down the avenue of cedars to make wooden tubs, whitewashing the mahogany staircase and selling off the lead in the roof and the paneling on the walls. Even bricks from the graveyard wall and tombs were sold for a little more cash. Rosewell fell into kinder hands in later decades but was ultimately destroyed by fire in 1916.

WILLIAM FITZHUGH OF CHATHAM, STAFFORD COUNTY

He was called "that eminent horseman" by no less a turf historian than Fairfax Harrison, and he is included in Hervey's short list of distinguished turfmen of the Revolutionary period. William Fitzhugh was a friend to George Washington, who shared his love of fast horses.

William Fitzhugh's father died when he was just a boy, leaving him the heir to a vast fortune. His mother, the daughter of the fabulously wealthy Robert "King" Carter, soon remarried to another famous horseman, Colonel Nathaniel Harrison of Brandon. William Fitzhugh (1742–1809) is believed to have been educated in England. In America, he served as a member of the House of Burgesses, all of the Revolutionary Conventions and the Continental Congress. He built Chatham between 1768 and 1771, naming it after his mentor William Pitt, the Earl of Chatham. Pitt had spoken in the House of Lords against the Crown's heavy taxation on the colonies.

Chatham is located on the heights across the river from Fredericksburg and served as Union headquarters during attacks on Fredericksburg in the Civil War. It is but scant miles from Ferry Farm, Washington's boyhood home. In the town were located the homes of Washington's brother Charles and his sister, Betty Washington Lewis. Later on his mother, Mary, also lived in Fredericksburg. Even after he inherited Mount Vernon on the Potomac River, Washington was still a frequent visitor both to his family's homes and that of his old friend, William Fitzhugh.

Washington wrote to Fitzhugh, "I have put my legs oftener under your mahogany at Chatham, and have enjoyed your good dinners, good wine, and good company more than any other."

The Washington connection continued when George Washington's adopted son, G.W.P. Custis, married Fitzhugh's youngest daughter, Mary. Their daughter, Mary Anna Randolph Custis, would marry a young army officer named Robert Edward Lee.

Fredericksburg was a racing center in the eighteenth and nineteenth centuries, and Fitzhugh was a leading light of the times. At Chatham he entertained lavishly and had his own track built on the property. He also entertained at George Weedon's tavern in the 1760s and early 1770s. He hosted, among others, the Fredericksburg Jockey Club.

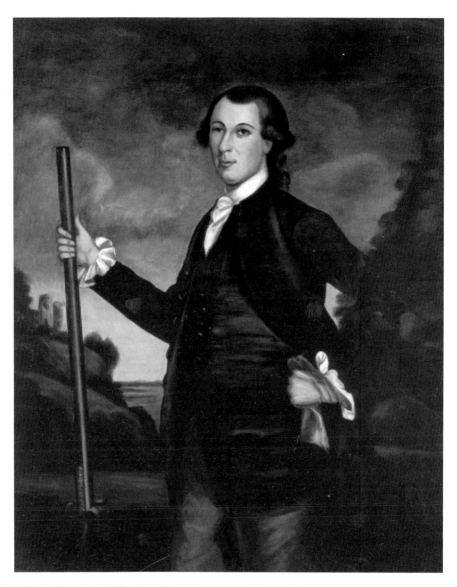

William Fitzhugh of Chatham. *Courtesy of the National Park Service.*

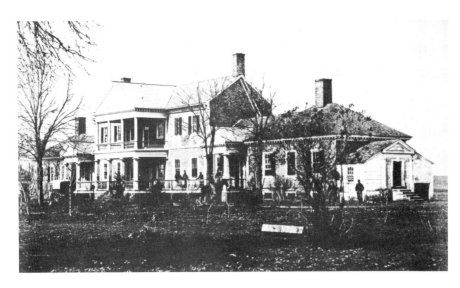

Chatham. *Courtesy of the National Park Service.*

"The merry accident." Courtesan Kitty Fisher is attended by numerous men after a fall from her horse. *Courtesy of the Library of Congress.*

Some of Fitzhugh's most famous horses were Brilliant, Gallant, Othello, Master Stephen, Regulus and the gray mare, Kitty Fisher. Kitty Fisher, a daughter of Fearnought, was likely named for the notorious courtesan who was the beloved of so many British noblemen. Fitzhugh's Kitty Fisher was a mighty fast filly, winning many times, including a fifty-guinea purse at Annapolis, Maryland, on September 27, 1773. Fitzhugh also raced his horses at Port Royal, Upper Marlborough, Leeds Town and, of course, Fredericksburg. The last big, four-day meet of colonial Virginia was apparently held at Fredericksburg in October of 1774.

Washington was likely in attendance to see his friend's horse Regulus take the Jockey Club Plate—one hundred guineas at four-mile heats—beating Spotswood's Eclipse (who won the first heat), Damon Figure, Faithful Shepherdess and Whynot.

As was often the case in the South, at least some of Fitzhugh's jockeys were slaves, as is evidenced by this 1785 will of his distant relative, Rose (Newton) Dade, which reads in part:

> *I give and devise to William Fitzhugh of Chatham near Fredericksburgh in Virginia aforesaid for and during his natural life the use of a Negro Man Slave called Gerard now in the possession of the said William Fitzhugh as a jockey or Groom and in the case the said Negroe Gerard should survive the said William Fitzhugh of my will and desire that the said Negroe be immediately thereafter manumitted & free and that he no longer thereafter be considered a slave.*

Toward the end of his life, Fitzhugh turned from horse racing to horse breeding. Chatham passed out of his hands when it was sold. Fitzhugh moved to Alexandria, where he remained a close friend to George Washington.

ALEXANDER SPOTSWOOD OF NEW POST

He was the grandson of another Alexander Spotswood—the entrepreneurial royal governor who led the Knights of the Golden Horseshoe on an exploratory mission and had Spotsylvania County named for him.

His father (Governor Alexander's son), John Spotswood, imported Jolly Roger, a significant early sire, and he stood at his farm from 1752

to 1758. John Spotswood also imported a mare named Creeping Kate at the same time, and did so in partnership with his brother-in-law, Bernard Moore.

Alexander Spotswood, the younger, was brigadier general of the Second Virginia Regiment and married Elizabeth Washington, the niece of the first president. He was also a racing enthusiast who bought fine imported horses and mares. He purchased the famous Shark, as well as three mares (Gunilda, Mambrina and an unnamed daughter of Sweetbriar), that he mated to produce some outstanding racehorses including Fairy (Ariadne), who would prove to be the downfall of the great gelding Leviathan. He had two strong contenders in that last pre-Revolution meet at Fredericksburg. His Eclipse was bested by William Fitzhugh's Regulus, a son of Fearnought. Spotswood's Stirling was trumped by another Fitzhugh horse, appropriately named Volunteer.

New Post is located just outside Fredericksburg, Virginia, at the junction of Route 2 and Route 17. It got its name from its origin as an early colonial post office, established by that first Alexander Spotswood.

GREEN BERRY WILLIAMS, LEGENDARY TRAINER

Although born in Georgia in 1778, Mr. Williams's parents were both Virginians and in time he would train many of the Old Dominion's best. Two of his uncles were killed in the Revolutionary War, and his surviving aunts and their families needed to be cared for. The combined families struggled to make a living, and Williams's father and brothers stayed interested in horse racing. Young Williams, while still a boy, became a well-regarded rider in quarter path races. He rode fine horses—descendants of Janus, including one named Ready Money.

Green Berry Williams went on to become one of the most successful trainers in history, working for more than seventy years. When he returned to Virginia, he trained for Hugh Wyllie of Charlotte County, helping the stable earn more than £1,300 in Virginia currency the first year. He was a compatriot of William Ransom Johnson. He trained Ball's Florizel, who was considered the best but most vicious horse of his day. He also trained Wyllie's Marske for John Randolph. Randolph and Berry mutually admired each other's talents. Randolph predicted, correctly, that he would make one

of the first trainers in America. For his part, Williams had never heard of another man who knew so much or talked so well about horses. He refused to work for John Randolph exclusively, however.

Baylie Peyton asked "Uncle Berry" why he turned down Randolph's magnificent offer—$1,000 per year, a house, servants and half the horses' winnings. Uncle Berry replied, "Oh, yes. I could have made a fortune, but I was afraid of Mr. Randolph; he was given to strange fits of anger. I would have as soon been shut up in a stable with Ball's Florizel, and he unchained, as to have to live on the same farm with Mr. Randolph."

One of Williams's favorites was a Sir Archie son, Walk-in-the-water. He was a large, chestnut gelding who raced well until he was fifteen years old. Williams retired him, and let a man named Thomas Foxhall buy him with the clear understanding that he should not be raced again. But when a four-mile heat match race with the favorite Polly Powell had no takers, Foxhall broke his promise and ran nineteen-year-old Walk-in-the-water. Out of condition though he was, Walk tried and finished a heat. Green Berry refused to watch the race, declaring he would as soon see a fight between his grandfather and a boy of twenty.

Walk-in-the-water's start in life was the result of a generous impulse. Many people in Southside Virginia appreciated the fiddle music of one Peter Faggan, a free black man who was nicknamed "Cabin Point." Peter Faggan owed some money to Jarrard Weaver, who asked an officer of the law to go collect it. Major A.J. Davie, who was then Sir Archie's owner, suggested that "Cabin Point" pay Weaver back with music. Weaver said no. Major Davie then suggested that he give Sir Archie's stud services to the fine half-bred sorrel mare that Weaver had with him that day. The deal was done, the debt was paid and in due time the game racer Walk-in-the-water was born.

Green Berry Williams eventually moved to Tennessee, taking some fine horses with him. He spent years matching his horses against another titan of the turf, General Andrew Jackson, who would later become president of the United States. Jackson spent quite a bit of time and a whole lot of money trying to beat a mare in Green Berry's string named Haynie's Maria. But try as he might—he went so far as to have William Ransom Johnson send him a perfect pick to best Haynie's Maria "without regard to price"—he could not do it. Pacolet, the chosen horse, came up lame, and everything Jackson sent at Haynie's Maria saw naught but her heels. At

the last, however, General Jackson would come around to the little mare's side. When her owner said he would match her at four- or one-mile heats against any horse in the world, the general replied, "Make the race for $50,000 and consider me in with you. She can beat any animal in God's whole creation."

The Antebellum Years

As the state grew in population and sophistication, the look of the race fields was changing, too. By the 1820s, grandstands were becoming more common. Originally the stand was a small structure only for the judges' convenience, but unruly crowds on the ground made a separate building desirable for "ladies and gentlemen." Ladies did attend the races, and in the stands they might place a regular wager or put up something small such as gloves or bonbons. The stands themselves were not fancy quarters. They were judged by some to be so flimsy that they got the nicknames "gallery" and "scaffold."

Crowds had dropped off by the 1840s. Purses were also lower. In an effort to attract more customers, those running the tracks built giant grandstands, holding between one and three thousand people. Now everyone could be in the grandstand, which gave a different atmosphere to the races. Gambling increased, and rather than betting one to one, the professional bookmaker came on the scene. It seemed to be more about money and less about the horses themselves.

Another change was the increasing number of races held in a single day. In the old custom, one major race was held per day. Later on, races would be staggered between heats. While the horses from the first race were cooling off, readying for the next heat, a second race would begin. To keep the crowds coming, the rival tracks in Richmond—Broad Rock, Fairfield, New Market and Tree Hill—ran their races on subsequent weeks.

But by the 1830s, racing in Virginia was clearly in a decline. The Old Dominion was certainly losing its status as "the Racehorse Region." When

the British ambassador had asked authority John Randolph whether Virginia could still be considered the nursery of champions, Randolph opined, "No, sir! No, sir! Since we gave up horse racing and fox hunting and turned up the whites of our eyes, our horses as well as our men have degenerated."

FINE DAYS FOR THE RICHMOND COURSES

Richmond's famous racecourses have entirely vanished from the scene, but place names give some clues as to their locations. Where was Fairfield? To get an idea of its location, on a map of Richmond, look for Fairfield Avenue and Fairfield Road. Fairfield was about two and a half miles southeast of Capitol Square, rather near the James River. Fairfield was a popular course because of its easy access to the capitol. Fairfield was the city dwellers' choice. As reported by Hervey, one of its frequent visitors wrote of its heyday, "Grave judges adjourned their courts, presidents of banks deserted their seats, and distinguished lawyers dropped their briefs to dispense, respectively, the light of their learned and financial phizzes on the occasion of some great contest of frantic interest to tiers of counties on either side of the upper or lower James."

Tree Hill was the home of the Richmond Jockey Club, and it was also the home of Diomed. Miles (J.M.) Selden was the first known manager of the Tree Hill plant. He not only ran the course, he also owned racers and ran a stud farm. He and Thomas Goode bought Diomed in partnership and had him at stud at Tree Hill. It was at Tree Hill that Diomed sired Sir Archie and Potomac (1804) and Duroc (1805). The Selden family ran Tree Hill until just a few years before it vanished in 1839.

The clubhouse at Tree Hill was set neatly on a small hill, surrounded by oak trees. The stables, also situated amongst the trees, could house fifty horses. From the front of the clubhouse was a view of the race field. From behind, the view was either of Richmond's skyline or the James River running down and away into the Tidewater. There was room to sleep fifty at the clubhouse, and the dining room held hundreds. The entire establishment was surrounded not by a fence but by a ditch, eleven feet wide and six feet deep, and was regularly patrolled, for an entrance fee was charged: a single person on foot or horseback could enter for a quarter, two-wheeled vehicles for fifty cents and larger ones for a dollar. The average gate receipts were $1,200 a year. The ladies had a separate stand for viewing the races.

Coaches at Jerome Park, New York, on a race day. *Harper's Weekly*, 1886. *Courtesy of the Library of Congress.*

Broad Rock came after Fairfield and Tree Hill. It was located south of the James River, about equally distant from the center of the city as Tree Hill. Its name is maintained by Broad Rock Road, and it has been built over completely through the years. In 1916, John Hervey had the pleasure to visit it even in its urban entombment with W.J. Carter, a Richmond turf writer who used the pen name of "Broad Rock." Carter was able to show Hervey a dying tree where he knew that in April of 1836, wicked Boston was saddled for his first race. But in its day, Broad Rock was considered the fastest of the Virginia tracks, faster by far than neighboring Tree Hill or Fairfield.

Grandstands appeared in Virginia certainly by 1808, when Banks Moody, proprietor of the New Market Course (also known as Newmarket) at Petersburg, ran this advertisement:

> *The subscriber who keeps the New Market Course has proved from long experience that to serve the public attentively and moderately are the most certain means of being remunerated for his labor, that he is therefore determined that every exertion shall be made on his part to promote the convenience and add to the amusements of those who may visit the races.*

An elegant stand 100 feet in length is already built on the field in which sumptuous dinners will be served up each day of the races. The advantages of being protected from inclement weather or the hot sun, feasting on the fat of our land and quaffing the choicest liquors all in full view of the contending coursers must greatly add to the gratification of the gentlemen.

The New Market course was designed for the elite, and no trace remains of it today except written memories. Behind the clubhouse was a lovely flower garden with white gravel walks. A pointer named Dash considered it his duty to accompany the judges to the stands, attend their inspection of the horses between races and remain with the officials until the races were done.

The stables themselves were not large, gaping barns. They were small stables, containing perhaps four stalls each, and were located in a shady grove rather than in the blazing sun. Many were privately owned. New Market's clubhouse kept its own kitchen garden on the premises, as well as its own cows for butter, milk and cream.

The cream wasn't only on the table at the racecourse. The New Market Jockey Club boasted Miles Selden, William R. Johnson, William Ball, John Hoomes, Thomas Goode, Richard Bland and John Hoomes Jr. among its founding members in 1803. Soon after, Wade Mosby, Robert Spotswood and Edmund Harrison joined the club.

According to Hervey, by 1839 there were fifteen active courses in Virginia. In the next decades, they would gradually fall away, one by one. By the 1850s, Tree Hill was no more, although two other Richmond-area tracks, Broad Rock and Fairfield, remained.

THE GREAT DEPRESSION OF THE 1830s AND '40s

Few these days have heard of the tremendous nationwide financial debacle that came to be known as the Panic of 1837. A credit boom followed by a credit crash led to a staggering number of bank closures. Untrustworthy paper (as opposed to gold and silver) money and fickle foreign investments added to the disaster. The federal government, then headed by race enthusiast Andrew Jackson, refused to step in. He had already given the despised National Bank's money to the states. They used the newfound cash to make some rash decisions that resulted in property foreclosures.

After the land losses there came the business losses, and the effects of these were felt by the entire population. Bankruptcy was rampant. With the economic bubble of the 1830s a faded memory, many Virginians tried their luck moving west to Kentucky and Texas. Even if the Virginians themselves did not go, many of their horses certainly did. Yet for all of that, an 1839 *Turf Register* records that Virginia, with thirteen independent tracks managed by their own jockey clubs, hung in at second in the nation to Kentucky, which had seventeen independent tracks. Likewise in 1839, Virginia had slipped to third place in number of Thoroughbreds standing at stud to the general public, behind Tennessee and Kentucky.

The best of Sir Archie's foals grazed on Kentucky bluegrass, and to this day it is Kentucky that has adopted the well-earned title of "the Racehorse Region." True, Kentucky was carved from the Old Dominion, as were many states, but those pastures were over the hills and far away from either old Tidewater or Southside Virginia. One of the first racers to enter Kentucky in 1801, according to the *Register of the Kentucky Historical Society* (1917), was a horse named Regulus from Colonel Hoskins's Mount Pleasant stable, a gift to his son William.

As an example of Kentucky's success, when turf historians talk about the truly great horses, Lexington's name is always mentioned. One of the last foals of wicked Boston, Lexington was bred by Dr. Elisha Warfield of the Meadows farm in Lexington, Kentucky. The blood bay colt was originally called Darley but he was renamed Lexington by his new owner, Richard Ten Broeck. His stiffest competition was another son of Boston, named Lecomte. Lexington was retired at a rather young age because, like his sire before him, he was going blind. He became known as "the Blind Hero of Woodburn." He stood in Kentucky until his death in 1875. Lexington was named Leading Sire for many years. A leading sire's status depends on the yearly earnings of his offspring.

THE HARNESS RACERS

Trotting and pacing races became more popular in both North and South during the nineteenth century. There was no particular breed requirement, but Thoroughbreds were popular both as racers and as foundation stock. Thoroughbreds that raced in a regular galloping competition one month

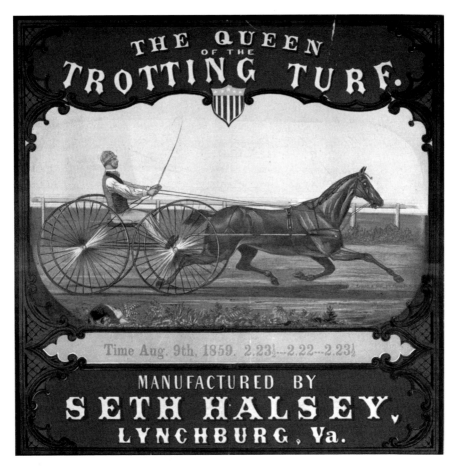

The Queen of the Trotting Turf (1859 tobacco advertisement), Seth Halsey, Lynchburg, Virginia. *Courtesy of the Library of Congress.*

might take to the trotting track the next. Ultimately a new breed called the Standardbred would dominate, and most of those were descended from a horse named Hamiltonian 10, the great-grandson of imported Messenger. Messenger was brought to New York at about the same time that Diomed was brought to Virginia.

Trotters and pacers had the distinct advantage of being versatile horses that ordinary people might own. One day they might win a race for their owners at the county fair and the next they might take the family to church. Because they were absolutely required to be disciplined and maintain nothing more than a trotting or a pacing gait in their races, they tended to be steadier and more reliable for everyday use than their galloping cousins. They might

trot under saddle or pulling a lightweight cart called a sulky. As the years went on, harness racing became a strong rival to the established race meets. Some old-time courses tried to get more income during their fading years by adding harness racing to their sponsored events.

DISCOVERY OF A NEW PLANET

The last bright light of the antebellum Virginia turf was Planet. Boston's grandson was foaled in 1855, at Major Thomas W. Doswell's Bullfield stud. Bullfield was one of the Doswell family farms in Hanover County. *The Spirit of the Times* gave this Virginia breeder "first position as an American turfman." Bullfield had not one but three training tracks and was well equipped to train the latest generation of horses before the outbreak of the Civil War.

Planet's first victory, as a three-year-old, was on his home racecourse for the Doswell Stakes. He went on to race and win throughout the South, in Petersburg, Richmond, Savannah, Charleston, New Orleans, Mobile, Ashland and Augusta. He ran in a very classy field for the Great Post Stake at Metairie, where the betting pool ran over $27,000. He won it, as well as the race that was named for him the following year, the Planet Post Stake.

His supporters tried to make another North-South match for Planet in 1860, but there was no one in his league to challenge him. One horse did dare to put in an appearance at the newly named Fashion Course on Long Island. Planet won in a single heat, a rare accomplishment, by easily distancing his opponent, beating him so ruinously that another go was out of the question. Planet's orbit extended to another racing field: the trotters. He could trot as well as he could gallop, prompting the superintendant at the Fashion Course to order his jockey to "take that trotter off the track."

Planet retired at the start of the Civil War. Out of thirty-one races, he won twenty-seven times, and for the other four he came in second. His lifetime earnings were $67,700, and he replaced champion mare Peytona as the leading money winner. His racing story came to an end with the war's outbreak, but being part of the Doswell stable, he is linked to some of the greatest horses in modern history.

After the Civil War, Major Doswell took on as a partner a fellow Confederate, Captain R.J. Hancock. Maintaining Doswell's orange racing silks, Captain Hancock would in time take over the entire stud operation.

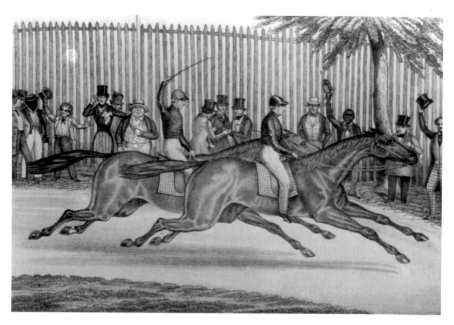

"Great race between Peytona and Fashion for 20,000!!!" *Courtesy of the Library of Congress.*

He moved the horses to his wife's ancestral home of Ellerslie, near Charlottesville. His son, A.B. Hancock, would marry a Kentucky lady. A.B. Hancock maintained two residences and two stud farms into the first part of the twentieth century. His second farm was called Claiborne, and it became an outstanding breeding farm.

Although they gave up Ellerslie in the twentieth century, the Hancocks still have ties to Virginia. Certainly many of their racers trace back to the great Virginia sires. Yet perhaps a most important tie is the mentoring that twentiety-century patriarch A.B. "Bull" Hancock Jr. gave to Penny Chenery. She owned a small breeding farm at Doswell, Virginia, called the Meadow Stable, and would use one of Mr. Hancock's prime stallions—a descendant of Boston and Eclipse—to breed a horse named Secretariat.

North and South: The Great Match Races

There have been regional cultural differences between the agrarian South and the mercantile North as long as the country has been in existence. It's amazing they were ever able to get together to work out a Constitution, let alone a Bill of Rights. Yet slow-talking Southern farmers and mile-a-minute Yankee city dwellers found common ground on the racecourse.

DUROC VERSUS DEFIANCE (1814)

Although technically not a North-South race—it was rather a South-South horse race between North-North owners—the Duroc versus Defiance match was a taste of things to come. Duroc, son of Diomed and soon to be sire of American Eclipse, was considered a brilliant horse and was thoroughly Virginia-bred. Duroc had sojourned to Oyster Bay, Long Island, in 1813 to become the property of New Yorker Townsend Cock and would pass his remaining days there, taking a little while away from stud duty to compete on the course.

A chestnut, standing at a sizeable 15.3 hands, Duroc lost races he should have won, all because of a terrible temper. One of his last races matched him against New York turf magnate Cornelius W. Van Ranst's big bay Defiance. Duroc, apparently uncontrolled by his inexperienced rider, bolted the course, losing in a most dramatic way.

Defiance, the victor, was another Virginia horse. His breeder was Major Roberts of Culpeper County. Defiance was the son of Ball's Florizel (a Diomed colt) and Miss Dance, who traced her lines several ways to the Godolphin Arabian.

Van Ranst would later buy Duroc's best son, Eclipse, for $3,000—a purchase that would guarantee another dramatic victory within a decade. Duroc's half brother, Sir Archie, would go on to become a legendary sire down South, but Duroc will always be remembered for giving Northerners their Eclipse.

HENRY VERSUS ECLIPSE (1823)

By 1822, the eight-year-old Eclipse (often called American Eclipse) was undefeated on the turf. Sir Charles, a Virginia horse and son of Sir Archie, was a natural choice to take on the Long Island legend. He had a record of twenty wins and four seconds in twenty-four starts. His owner, James J. Harrison, sent the challenge to Van Ranst, who accepted. Four-mile heats, at $5,000 a side, were to be run on November 20 in Washington, D.C.

A large crowd assembled at the district's course. But they were doomed to disappointment. Sir Charles injured a tendon while working out. Harrison had to pay the forfeit, but he decided to run Sir Charles against Eclipse for just one four-mile heat. The payoff would be $1,500 a side, and the crowd would not go home completely bereft of their day of excitement. Four miles proved to be too much for the injured Sir Charles. He ran well for three of them but then he completely broke down, and Eclipse galloped home unchallenged for the last mile.

That evening, adopted Virginian William Ransom Johnson, the Napoleon of the Turf, set his own challenge for Eclipse. Still smarting from Sir Charles's defeat, he declared that on the last Tuesday in May of 1823, he would run a horse against the still unbeaten Eclipse over the Union Course. Once more the rules were to be four-mile heats, with the astronomical sum of $20,000 put up per side. The $3,000 forfeit was certainly a princely amount. Barring total disaster there would be a race—a tremendous race, the likes of which the still young nation had never before seen.

Syndicates were formed in both the North and South to come up with the necessary cash. Clever William Ransom Johnson had the enjoyable

Sir Charles, from a painting by A. Fisher. *From* The American Turf Register, Sportsman's Herald and General Stud Book.

task of picking the best Southern horse or mare to accept the challenge. He narrowed his choices down to five. He had two that were experienced four-milers—Betsey Richards, the daughter of Sir Archie, and another good horse named Childers. He had an additional three young creatures that were untried over "the heroic distance" but which he was willing to train and test. These three were John Richards, a bay brother to Betsey Richards; Washington, a son of Timoleon; and Henry, the plainly named chestnut son of Sir Archie. Johnson tried them at Virginia tracks in the spring. Henry triumphed over his half sister Betsey Richards in two straight heats, setting a track record with times of 7:54 and 7:58.

Clearly, Henry was the favorite of the five. Johnson loaded him onto a boat and journeyed to Pennsylvania, where he completed his training before the big race. According to William H.P. Robertson, 60,000 people were reported to have witnessed the race, a tremendous number since New York only had a population of 150,000. Surely that many could not be struck with racing fever. And yet it was also reported that a full 20,000 people traveled tremendous distances from the Southern states for the race.

John Randolph, Esquire. *Courtesy of the Library of Congress.*

North and South: The Great Match Races

In the crowd were the notable and notorious, including Andrew Jackson, then serving as first governor of Florida, and Aaron Burr. A former vice president, Burr had faced international political and social disgrace since killing fellow statesman Alexander Hamilton in a duel in 1804.

Such a fine contest between racing champions naturally drew John Randolph of Roanoke like a bee to nectar. Eclipse was Long Island born, and Henry was the pride of the Southern turf. For a horseman who believed firmly in states' rights, the excitement of this war between the states was sufficient to lure him hundreds of miles to the race field.

By the day of the race, odds were in favor of the newcomer Henry. After all, Eclipse had not raced since the previous fall, and Henry was the scion of the South. Cadwallader R. Colden, who wrote sporting stories under the name "An Old Turfman," applied his unique style of sports coverage to the event. Mounting his own horse, he rode alongside of Henry and Eclipse so that he could better report his impressions. His amazing account survives to this day and is reprinted here in parts.

After the first heat, which Henry won in blazing time, setting a national record of 7:37½, Colden reflected sadly on Eclipse's demeanor: "Crafts [Eclipse's jockey], in using his whip and struck him too far back and had cut him not only upon his sheath, but had made a deep incision upon his testicles… The blood flowed profusely from one or both of these foul cuts…and gave a more doleful appearance to the discouraging scene of a lost heat."

The next heat saw a change in jockeys for Eclipse. Cruel-handed Crafts was replaced with retired jockey Samuel Purdy. Purdy had ridden Eclipse years ago and once mounted he brought about a sea change in the horse's fortunes. He rode him close to Henry for three miles. Then he made his move, cutting along the inside to save ground and sweep to the finish. The time for this heat was slower (7:49), but the excitement had risen, and one statesman by the name of John Randolph of Roanoke found himself carried along with the fever pitch.

Josiah Quincy, a Puritan from Boston, witnessed the race and described the commotion surrounding the second heat:

> *Directly before me sat John Randolph, the great orator of Virginia…Apart from his great sectional pride…he had bet heavily on the contest, and it was said, proposed to sail for Europe upon clearing enough to pay for his expenses…*

...Sir Henry took the inside track, and kept half the lead for more than two miles and a half. Eclipse followed close on his heels and, at short intervals, attempted to pass. At every spurt he made to get ahead, Randolph's high pitched and penetrating voice was heard, each time shriller than before: "You can't do it, Mr. Purdy! You can't do it, Mr. Purdy! You can't do it, Mr. Purdy!"

But Mr. Purdy did do it...and although I had not a cent depending I lost my breath, and felt as if a sword had passed through me...

...The confidence on the part of the Southern gentlemen was abated. The manager of Sir Henry rode up to the front of our box and, calling to a gentleman, said: "You must ride the next heat; there are hundreds of thousands of Southern money depending on it. That boy don't know how to ride; he don't keep his horse's mouth open!"

The gentleman positively refused, saying he had not been in the saddle for months. The manager begged him to come down, and John Randolph was summoned to use his eloquent persuasions. When the horses were next brought to the stand, behold the gentleman appeared, with a jacket on his back, and a jockey cap on his head.

The obliging gentleman was Arthur Taylor, William R. Johnson's head trainer. English-born Taylor was called Talleyrand for his vital importance to the Napoleon of the Turf. He had handled Sir Archie, and now he was to try to ride the son to victory. As a side note, Taylor would later go on to train another legendary racehorse, Sir Archie's grandson, Boston.

Despite Randolph's entreaties, Purdy did it again, urging exhausted Eclipse past exhausted Henry in the third heat for the overall win. The time was much slower than the previous heats, at 8:24, but by this time the stallions had run eight miles going on twelve, so it was hardly surprising. Henry lost the race in its entirety, but he earned the distinction of having been the only horse to ever beat Eclipse for even one heat, and he did it while setting a national record.

It was not William Ransom Johnson who frantically implored Taylor to get aboard. That was another manager named Otway P. Hare. The Napoleon missed the event entirely. He was indisposed at his hotel, having overindulged either in oysters or lobster at a champagne dinner the previous evening. But the Napoleon was not an easy loser. He immediately penned a note to John C. Stevens, a major shareholder of the Northern syndicate, asking for a rematch.

Sir—

I will run the horse Henry against the horse Eclipse in Washington City, next fall, the day before the Jockey Club Purse is run for, for any sum from twenty to fifty thousand dollars, forfeit $10,000. The forfeit and stake to be deposited in the Branch Bank...

...Although this is addressed to you individually, it is intended for all the bettors on Eclipse, and if agreeable to you and them, you may have the liberty of substituting for Eclipse, any horse, mare or gelding foaled and owned on the northern and eastern side of the North River; provided, I have the liberty of substituting in the place of Henry any horse, mare or gelding foaled on the South side of the Potomac.

Stevens declined, and Johnson would have to return southward without a promised rematch, but eventually the Southerner would have a final victory by purchasing Eclipse, by then long retired to stud service.

The famous race had a tremendous impact on horse breeding. The three grandsons of Diomed were in high demand, so much so that, according to Hervey, it was soon necessary to send for fresh English stock to add variety to bloodlines that had stagnated due to inbreeding. He quoted the ever-observant Benjamin Ogle Tayloe: "A few years ago the prominent stallions of our country were all of one blood. If a man wished to raise a blood colt what was the fact? Why, he had only to determine whether his mare, she, too, of the Archie stock, should be put to Henry, Sir Charles, or Eclipse!"

ARIEL VERSUS FLIRTILLA (1825)

The family feud kept going when Eclipse's three-year-old daughter Ariel faced off with the five-year-old daughter of Sir Archie and thus half sister to the defeated Henry. The bay Flirtilla was the Southern entry, owned by Colonel William Wynn, trained and managed by William Ransom Johnson. Ariel and Flirtilla ran for $20,000 with an extra $10,000 in side bets. Rather than running the full four miles at a go, the distance was set at three miles per heat over the Union Course, Long Island.

The gray filly Ariel, like her sire Eclipse, was bred on Long Island. She won the first heat, but the older mare Flirtilla won both the second and third

trials. Although this time Colonel Johnson's entry won, he was so impressed by Ariel's form that he purchased her on the spot and took her back home to Virginia. Ariel went on to have a career total of forty-two wins out of fifty-seven races.

Flirtilla, unlike her rival, maintained her fame through the next generations. She became known in studbooks as Old Flirtilla when her daughter Flirtilla became a well-known racer in her own right.

POST BOY VERSUS JOHN BASCOMBE (1836)

Post Boy seemed to be the North's best hope for revenge. The dark chestnut was the pride of his New York owner, Robert Tillotson, and had swept away the competition in his territory and some Southern horses also. His owner had set a date for a duel with the very best the South could produce. The race was scheduled for May 31, 1836, but as of April 12 a contender had yet to emerge. When finally a horse emerged from the herd, Southerners were intrigued. Everyone had heard of Post Boy—probably the best racehorse since American Eclipse.

But who was John Bascombe? This relatively unknown colt, foaled on a Tennessee farm, was named for a traveling Methodist minister who had impressed the horse's first owner. The colt was a bit of a late bloomer, performing poorly in his early races. He traded hands several times before landing in the stables of Colonel Crowell. In the kind of racing luck that seems to bless come-from-behind champions, John Bascombe got his chance when he was needed to fill in for better-classed stable mates in a $17,000 four-mile heat match race.

Rather than forfeit, Colonel Crowell ran the little horse, who pulled a Cinderella-like performance to best Colonel Wade Hampton's Argyle in good time. As James Douglas Anderson phrased it, "A new light had come to the South."

The overnight success was handed into the tender care of the Napoleon, who walked his new charge all the way to Long Island. As he made his journey, crowds gathered to marvel at the youngster and cheer him on to victory. He was rested at Petersburg before continuing on and arrived in Long Island in excellent condition.

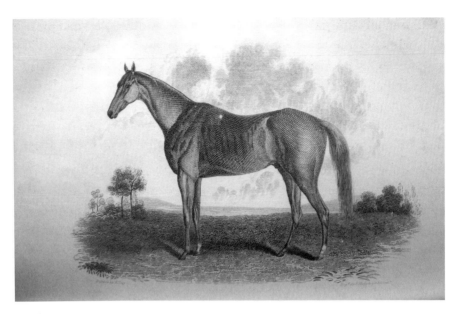

John Bascombe, from a painting by E. Troye. *From* The American Turf Register, Sportsman's Herald and General Stud Book.

Colonel Johnson's favorite jockey, a man named Willis, was chosen to ride the contender, while Gilbert W. Patrick was in the irons for Post Boy. Post Boy had the inside position at the start. The drum tap sounded, and the race was on.

The Southern colt won the first heat handily in 7:49. Both horses seemed fresh as they headed to the post for the second heat. For this running, the spurs were fully applied by both jockeys, but an observer commented that for Gilbert Patrick, "the rowels were laid in up to the shank, claret was tapped, and his whip-hand at work. Under persuasions like these, Post Boy drew out a head and neck in front."

But John Bascombe maintained his stride, pushed harder and as they came down to the last turn they were running neck and neck. Post Boy tried a final rally, but it was no good. One last push from Willis, and the star from Alabama sailed to victory by a length. The time, 7:51½, was scarcely slower than that of the first heat.

As a final touch, C.W. Van Ranst was on hand to present the victor a most unusual honor—Eclipse's tack: his saddle, bridle, riding silks and spurs, which was worn "in the first great strife between Northern and Southern horses."

Once more, the laurels went to the South and the North was gracious in defeat, although hedging a little, as a newspaper editor wrote: "The South

has beaten us fairly and honestly on our own ground. We give them joy of their victory. The trophy now goes from us, but how long shall the South retain it?"

BOSTON VERSUS FASHION (1842)

How long, indeed? The next great match wasn't to come for six more years. This time it was arrogant Boston, bane of the Northern tracks, facing off against the filly Fashion. On May 10, 1842, Union Course was engulfed by a crowd of seventy thousand spectators, including forty senators, who had turned out to see another epic race, with $20,000 staked per side.

There were tremendous problems with crowd control, according to a contemporary account in the *Turf Register*, but some tough New Yorkers managed to bring peace to the scene:

> *At one o'clock, however, owing to the want of an efficient police, and their inability to see the race, more than a thousand persons climbed over the pickets, from the field into the enclosed space while a mob on the outside tore down a length of fence, and stove through a door in the stand, and swarmed into the cleared space. For a time it seemed impossible for the match to take place at all! A crowd of loafers made a rush up the stairs leading to the Club Stand, but they were summarily ejected. At length Yankee Sullivan, Jeroloman, and several other distinguished members of the Fancy, undertook to clear the course, which they did in an incredibly short time, by organizing a party of their friends, who formed in line, with clasped hands, quite across the space, and marched from one end to the other, thereby driving outside of the gate every person without a badge. Of course there were among this mob several ugly customers, but Yankee Sullivan had only to "let fly with his right," or Jeroloman give any one of them "a teaser on his smeller," to fix his business! On the whole, the mob conducted themselves very well under the circumstances; the great majority were in perfectly good humor, and had the proprietors taken the precaution to paint the tops of the pickets with a thick coat of tar, and engage a strong body of police, no such disgraceful scene would have occurred.*

Small bronze figurine of Boston. *From the author's collection.*

As to the horses themselves, they found the track to be not quite fast, but the day was warm and not overly sunny. Fashion, a five-year-old chestnut mare, faced an experienced if ill-tempered horse described in the *Turf Register* as a formidable opponent: "Though he has occasionally sulked, Boston runs on his courage, and is never ridden with spurs. He is no beauty, his neck and head being unsightly, while his hips are ragged, rendering him 'a rum 'un to look at;' that he is 'a good 'un to go.'"

Boston had won thirty-five of his thirty-eight races, many at the heroic four-mile heat distances, and was being trained by none other than the man who had ridden Henry so many years ago, Arthur Taylor. As an aged horse, he was given the doubtful honor of carrying 126 pounds to Fashion's 111.

Fashion was a Northern lady with a fast reputation. She had been badly worn by a contest the previous spring and had been given a nice long rest before resuming racing.

In the first heat, Boston led the way but was pulled up by his jockey and then maneuvered for another rush. Gil Patrick reined awkwardly, and Boston smashed his hip against a rail, cutting himself badly to a length of at least seven inches. Fashion took the lead by several lengths while Boston rallied bravely. At this moment, thousands of excited fans broke through the rail and nearly blocked the paths of the horses. Both horses hesitated but continued under the whip, and Fashion's rider "tapped the claret"—raking her with his spurs until the blood flowed—inciting her to finish a length ahead. The time, 7:32½, was the fastest four miles yet run on the American continent. So ended the first heat.

The second heat began a near thing as well, Fashion first leading and Boston soon catching and surpassing her. Fashion took a little time to fall back and rest while Boston ran himself out. Fashion soon rallied and ran away with the race, leaving Boston sixty yards behind her. The time was a thoroughly respectable 7:45. The total victory belonged to Fashion.

But Boston got a bit of revenge no later than the Friday following the match. It was then that he bested Mariner, Fashion's half brother, biting him in passing at a full gallop as he had done to the sister in the last match. He also tried to bite the rival jockey, giving him a tremendous scare. Boston may have been beaten by the lady of Fashion but he was certainly unbowed.

PEYTONA VERSUS FASHION (1845)

Another year, another match race. Peytona carried much Virginia blood in her, but she, like John Bascombe, was foaled in Tennessee. She rose to fame as a result of a homegrown antebellum economic incentive package: a futurity race for foals yet unborn, with the richest stakes thus far in history. Colonel Baylie Peyton, who would later coauthor *Making the American Thoroughbred: Especially in Tennessee*, set the race up in 1838 for the unborn foals of 1839, to be run at Nashville in 1843. It cost $5,000 to subscribe, with $1,000 to pay for forfeit, with the total value of the purse rising to an incredible $150,000.

A huge young mare with a twenty-seven-foot stride and the unprepossessing name of Glumdalclitch (she was named for a giantess in *Gulliver's Travels*) took the prize and promptly became the hottest property on the continent. This daughter of Giantess received queenly treatment thereafter and was

North and South: The Great Match Races

Peytona and Fashion: in their great match for $20,000. over the Union Course L.I. May 13th. 1845, won by Peytona, time 7:39¾ 7:45¼. Currier & Ives. Courtesy of the Library of Congress.

renamed Peytona, in honor of her great victory—for the race that had been named for Colonel Peyton.

As Peytona, she was moved by her South Carolinian owner Wade Hampton II down to New Orleans. The queenly mare earned a royal advisor, none other than Colonel William Ransom Johnson. Acting as consultant, he engineered the last great match race of the antebellum period. Peytona would take on Fashion at the Union Course. Though it had only been three years since Boston's defeat by Fashion, Colonel Johnson was confident as he led her through the admiring crowds northward to the Long Island course.

The racetrack swelled with crowds estimated between 70,000 and 100,000 people. They were head to head for much of the first heat, but then the challenger came on strong. This account is taken from the contemporary source, *The Spirit of the Times*, which was reprinted in its entirety in *Making the American Thoroughbred* and is excerpted here:

> The claret was tapped on both sides, but Peytona's youth, strength and stride told, at last, as did her competitor's, in her match with Boston. Before reaching the hill, Peytona drew out in front, and the heat was all over but the shouting! Laird bottled up his mare around the turn, and tried it

on again up the quarter stretch, but it was no use; Peytona outfooted her, and appeared with something in hand, by a length in the clear, though she, as well as Fashion, got a taste of cold steel between the draw-gate and the winning post. The fourth mile was run in 1:55¾, and the heat in 7:39¾.

So ended the first heat. In between, the mares cooled down, as did the reporters—with iced goblets of champagne, courtesy of a famed oyster house proprietor who scrambled "over carriages, horses, and the heads of all sorts of people" to supply the need.

During the excitement of the second heat, mounted men and carriages were "constantly dashing across the field from point to point" trying to get a better view. It was a hard-fought race to the very last:

From the draw-gate to the stand, the contest was as determined on one side, as it was desperate on the other! All at once the vast assemblage is quiet—then you hear a shout—it increases as the horses come nearer—it becomes tremendous—your heart somehow gets in your throat—you try to shout yourself—a thrill—a whirlwind of excitement—the winner flies past you—the race is over! Peytona wins the heat (time 1:58¼) and race without your hardly seeing daylight between her and her matchless competitor! Time, 7:45¼, and the most gallantly contested, as well as the most beautiful race ever seen in this country.

Fashion emerged from her defeat in good condition. Soon afterward, she bested a still-tired Peytona in another race. As broodmares, neither had much in the way of remarkable progeny, but one of Peytona's fillies passed down the giantess genes for females to some of today's runners.

The Thoroughbreds Join the Cavalry

Tourists the world over journey to Virginia's Civil War battlegrounds. They walk the gently rolling hills of the Piedmont and Shenandoah Valley. They see empty fields, gentle rises, rocks and fences. Perhaps they find some remaining earthworks. But unless visitors travel Ranger Mosby's old routes near Middleburg, they are unlikely to see the living, breathing reminders of those pitched cavalry battles peacefully cropping grass.

By the time of the Civil War, Virginia may have lost its title as the nation's Horse Race Region, but there was an abundance of truly fine Thoroughbreds and quality riding horses in its pastures. It had been less than a hundred years since the American Revolution called up the best of them, and this would be another bloodletting.

But the war did not start in despair. No, far from it! The young officers and enlisted men on both sides were convinced it would be over very quickly. Of course they brought their best horses with them, and these would make a difference.

Confederate General William Giles Harding, who owned the famous Belle Meade stock farm near Nashville, sagely commented:

> *Never did blood tell with more effect then in the beginning of the late Civil War when the successes of the Southern cavalry proved more than equal to the North, two to one. But towards the close of the war when the well-bred horses of the South fell into the possession of the Northern cavalry, this superiority failed to appear. A thorough scrub is incapable of either speed or endurance.*

Statue erected in memory of the 1.5 million horses and mules who died or were wounded in the Civil War, by Tessa Pullen. *Courtesy of National Sporting Museum, Middleburg, Virginia. Photograph by Steven Johnson.*

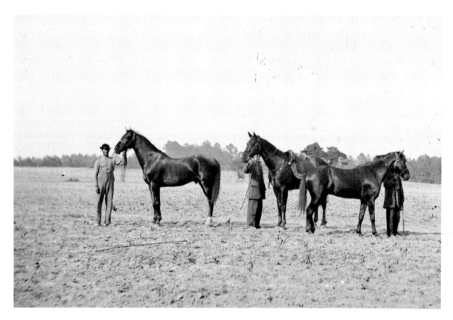

U.S. Grant's horses (left to right): Egypt, Cincinnati and Jeff Davis. Cold Harbor, Virginia. *Courtesy of the Library of Congress.*

Captain Perkin's horse "Sesesh" captured at Cornwallis cave, Yorktown, Virginia. *Courtesy of the Library of Congress.*

The Confederate cavalry was famous for its daring, but one military rule was to have crippling effects toward the end of the war. Unlike the Union cavalry, Confederate horsemen were expected to supply their own mounts. And when a horse died either from wounds or sickness, it was the soldier's responsibility to find another. This might mean weeks away from his unit while he traveled home to retrieve another mount.

The search for remounts was so unceasing that grand old Lexington, blind as he was, had to be evacuated to avoid being pressed into service. But his sons and daughters were certainly on the battlefield for both North and South, and one of them was gifted to Ulysses S. Grant. Cincinnati was his favorite mount. After the war, he accompanied President Grant to the White House. Grant commissioned a statue of himself astride Cincinnati, which can be seen today in Washington, D.C.

Most of the larger Virginia homes that lay in the path of the Union army bore the marks of occupation. Banister Lodge in Halifax County in earlier years played host to John Randolph of Roanoke. He was a friend and frequent visitor, borrowing and sharing books with its owners, the Clarke family. During the war, both General Lee and General Joseph E. Johnston visited Banister Lodge. The farm lost twenty-five of its fine horses during a Northern raid, to be pressed into wartime service with the enemy.

The Gray Ghost of the Confederacy

While massive armies clashed thousands at a time, a slight man with a jaunty air rode into legend as a guerilla raider. A country attorney in peacetime, John Singleton Mosby was also an excellent horseman. His family hailed from Albemarle County, where the family home, Tudor Grove, was located near Monticello. Mosby's Rangers, whose total numbered eight hundred by the war's end, took orders from Lee, Stuart and President Jefferson Davis.

Their mission was to harass and disrupt the Union forces. This they did excellently and with such verve that their stories continue to be told. Like Queen Elizabeth I's privateers, they plundered their enemies' stocks and sought to cut off their supply lines. They captured weapons, foodstuffs and, of course, horses. Each ranger was expected to have four pistols and four horses so he might always be ready to ride.

They might sleep in the rough or sometimes they would stay at neighboring farmhouses. The local young ladies enjoyed opportunities to socialize with the dashing young rangers in what had become "Mosby's Confederacy," consisting of Loudoun, Fairfax and Fauquier Counties in Northern Virginia. However, the Union troops were wise to this arrangement. At Belle Grove in Fauquier County, Amanda Virginia Edmonds recorded a near capture:

> *Much to our surprise, mortification and sorrow the slumbers of the house-hold were aroused by the rattling of swords and the clatter of horses, which fortunately made known to our dear soldiers that something was wrong. Bud jumped from his bed and there to his utter surprise were Yankees dashing up. Bud with Mr. Alexander and George dashed*

Portrait of Colonel John S. Mosby, Forty-third Battalion, Virginia Cavalry, CSA, and friend. Israel and Company (Baltimore). *Courtesy of the Library of Congress.*

down the stairs where Ma and I met them nearly frightened to death.
They dashed to their secret hiding place followed by overcoats, pistols and
everything I could grab up.

Most often Mosby would come through his adventures with all the polish and dash of a cavalier, but thanks to a newly captured bay, the commander nearly met a muddy defeat. He and a few of his men were riding the few

miles through the hills from Middleburg to Aldie when he came upon what he assumed was the rear guard of a much larger force.

He called for a charge and clapped his spurs to his mount's sides. Unknown to Mosby, this horse had never been ridden with spurs. They drove him mad with fear and fury. He reared up, took the bit in his teeth and made a dead run toward the Federal troops. As Mosby, who was ever inclined to sprinkle his speech with classical allusions, remarked, "I had no more control of him than Mazeppa had over the Ukraine steed to which he was bound." (Mazeppa, a subject made famous by Byron, Victor Hugo and Liszt, was a pageboy punished for his indiscretions at the Polish court by being strapped naked to a wild horse that ran to the Ukraine until it fell, exhausted.)

Mosby was not so helpless as Mazeppa. The bay ran past the mill; he ran past the Federal soldiers watering their own horses and over a bridge at breakneck speed toward a group of blue-coated cavalry. What they saw was a small figure wearing a plumed hat rise in the saddle, jump and land feet first on the muddy path. The Federals assumed that the Rebel must be the advance rider for a massive Confederate force. They turned their horses and fled at high speed, the maddened bay at their heels. And at the end of that encounter, Mosby and his men captured nineteen men and twenty-three horses, with all of their accoutrements.

THE MCCLELLAN SADDLE

One piece of Union equipment that the Confederates truly appreciated was a saddle designed by Union General George McClellan, or "Little Mac," as the Rebels nicknamed him. Before the war years, he had been sent to Europe to study its armies' cavalries. He came back with copious notes and ideas to turn out a new cavalry manual and a terrific new piece of tack that was called the McClellan saddle. The McClellan combined styles used by Hungarians in Prussian service with features of Mexican, Texan and other styles of saddles. Its most noticeable feature is its open center or "tree," as horsemen call it.

This style was more flexible. It came in three standard sizes and could easily be kept in stock to be changed out for a good fit on the remounts. When McClellan led the failed Peninsula Campaign early in the war, Mosby first tried and bested the Federals' rear guard, likely capturing some of those coveted saddles.

CROQUETTE: A SPLENDID WAR PRIZE

There came a day when Mosby and his rangers made off with $178,000 from commandeering a Union train. It was to be divided in eighty-four parts amongst the men, but Mosby would have nothing to do with the cash. So his men took up a collection amongst them and bought him a fine horse he had seen in a pasture at nearby Oatlands.

This horse, named Croquette, became his favorite. Croquette would follow his owner home after the war, along with others in his string of veteran mounts: a black horse named Raven, a large bay named Captain and a well-nourished, dapple gray gelding called Dandy. In the years just after the conflict, he added a few racers to his string: Dewdrop, Red Cloud and Eugenie—named for Napoleon III's empress. Mosby never wagered on the races himself. Peacetime racing was a sport to be enjoyed for its own sake.

FROM ONE CAVALRYMAN TO ANOTHER

Many years after the war, Mosby worked for the Southern Pacific Railroad's San Francisco office. While he was there, he made friends with a fellow Virginian, a gentleman who was the father of young George S. Patton. While visiting at the Patton home, Mosby and young George would talk about those long-ago raids and reenact them on the nearby Pacific beach.

George S. Patton attended the Virginia Military Institute and, like J.E.B. Stuart, graduated from West Point. As the old song went, he "jined the cavalry" before taking on tanks. He was a remarkable horseman. He went fox hunting, played on the army's polo team and, in 1912, achieved a perfect score for the five-thousand-meter steeplechase at the Olympiad in Stockholm—on a borrowed Swedish cavalry horse.

Forty years after his meetings with Mosby, General George S. Patton would use similar fast-moving tactics to win battles in Europe. Always an enthusiastic horseman, the general saved the famous Lipizzaner stallions from Russian capture. The stallions became, in Patton's words, "wards of the U.S. Army." In a move Mosby would certainly have approved of, he authorized a raid of more than one thousand horses from the German army, including the Lipizzaner mares as well as one hundred Arabians and two hundred Thoroughbreds.

J.E.B. STUART
"WE HAVE THREE THOUSAND HORSES..."

Reckless, gallant and an immensely talented horseman, J.E.B. (James Ewell Brown) Stuart was one of Lee's top commanders. John Singleton Mosby served under his command and thought well of him, writing in *Stuart's Cavalry in the Gettysburg Campaign*: "He was the rare combination of the Puritan and the knight-errant; in his character were mingled the graces of chivalry with the strong religious sense of duty of a Round-head. He felt intensely the joy of battle, and he loved the praise of fair women and brave men."

Larger than life, Stuart was full of fire for the Southern cause and his dashing good looks and chivalrous manner made women swoon. In between battles, he and his men would be entertained at fine houses, and it was not unusual to see young women flocking around him, begging a button from his uniform or a lock of his hair. Women from as far away as Baltimore sent him gorgeous gifts: golden spurs and a golden sash, among other tokens. He liked the spurs so well that for a time he signed himself in private letters, "The Knight of the Golden Spurs."

But for all the charm he bestowed on the fair sex in formal gatherings, his heart belonged to his wife, Flora. Though not so much a beauty, the sweetness of this army officer's daughter won her his lifelong devotion. He often asked that she visit him in camp and he set aside a favorite camp horse, Lily of the Valley, for her use. Stuart had another unusual quality for so sociable a gentleman: he never took a drink until the day he died.

Today, Culpeper is a quiet and small Virginia town, and so it has been for many years. But in early June of 1863, Stuart and his thousands of men were encamped there. In the normal course of events, an army encampment is a grim thing where citizens are advised to lock up their chickens and their daughters. But an encampment by Stuart's men might be a different experience altogether. That June, J.E.B. Stuart had decided to hold a celebratory formal ball for his officers and their ladies. The town hall was taken over for the event and it was done with as much flourish as his staff could muster. Ranking officers and political leaders, including Secretary of War George Randolph (a relation of that acerbic horseman John Randolph), flocked to the town for an evening's pleasure.

The Thoroughbreds Join the Cavalry

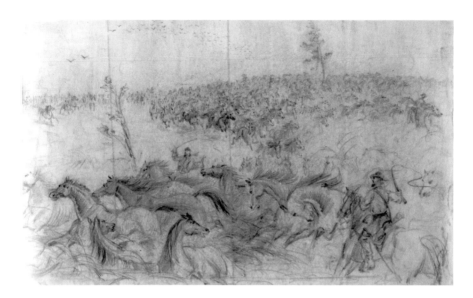

A stampede of army horses, by Alfred R. Waud. *Courtesy of the Library of Congress.*

Not everyone found the general's ball and the next day's grand review to be enjoyable. There were some jealousies and complaints from the war-weary rank and file. Perhaps they had a point. The next week's engagement at nearby Brandy Station was a bloody, huge fight—noted by some historians as the largest cavalry engagement of the Civil War. This was at the beginning of the Gettysburg Campaign. Neither side could really claim victory at Brandy Station. Stuart held the ground despite the surprise attack, but it was a turning point for the U.S. Cavalry troops, who were able to hold their own for once.

Stuart and his men were set to go into Maryland, looping around the capital toward Gettysburg. There was, however, a substantial obstacle in their way—the Potomac River. They had gone thirty-five miles through countryside stripped bare by foraging armies on both sides. Weakened as they were, it was necessary to cross the Potomac. Stuart asked for a volunteer to scout a crossing on a moonless night.

Captain R.B. Kennon rode his Thoroughbred, Big Indian, into the waters. He recalled that wild night, with no enemy to face off against save the river, though that was enough and plenty: "The Potomac was about a mile wide, the water deep and the current strong. The horse swam magnificently. When he tired I reached the Maryland side. The night was calm, but no moon.

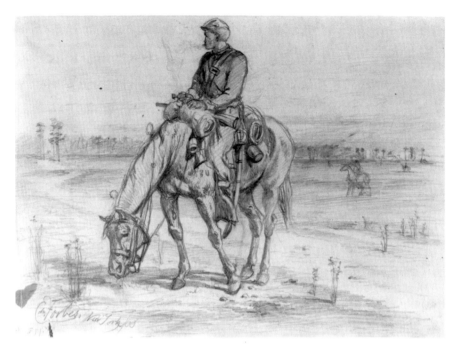

A cavalry vidette. Taking it Easy, by Edwin Forbes. *Courtesy of the Library of Congress.*

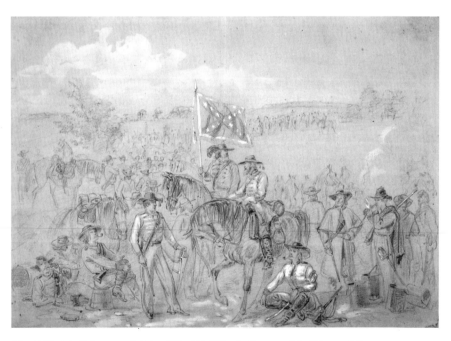

The 1ˢᵗ Virginia Calvary at a halt, by Alfred R. Waud. *Courtesy of the Library of Congress.*

Some rest for the horse was indispensable. However, as soon as the breathing of Big Indian came back to normal, I sprang to the saddle and we took the plunge to return."

When he got back to the friendly side of the river, a man reached out of the darkness and took hold of his bridle. It was Stuart. He had been waiting for him to return, yet expecting the worst. Kennon reported the daunting scenario of treacherous bottom, boulders and hidden depths. Clearly they were better off crossing at Rowser's Ford, the original plan. This was accomplished: six thousand troopers crossing high water at night, carrying shells in their hands to keep them dry. Later Stuart's officer, Major Henry B. McClellan, would opine that no more difficult achievement was accomplished by the cavalry in the course of the war.

Stuart's many horses served him well through the fighting. One of his favorites was a mare named Virginia, and her speed and strength saved his life on the road to Gettysburg. Stuart and Captain William W. Blackford were riding on a road lined with hedges on either side when they encountered the enemy. Laughing, Stuart brandished his saber, shouting, "Rally him, Blackford!" and the two took off over a hedge.

But they soon ran into a Federal flanking party that ordered them to surrender. They did not. They rode on, with pistol shots ringing around them through a field of tall grass. Neither of them saw the fifteen-foot ditch until they were nearly upon it. Up and over and across, both horses spanned the ditch easily. Blackford's mount, Magic, made the leap by a wide margin, reportedly twenty-seven feet. Stuart kept his seat perfectly during the leap.

He was to lose Virginia, but he found another horse on the other side of the Potomac. This one he appropriately named Maryland. At a friend's home near Shepherdstown, he wrote this comedic ode to his new steed, to the tune of "Maryland, My Maryland":

I feel secure upon your back,
Maryland, my Maryland!
When danger howls upon your track,
Maryland, my Maryland.
You move me o'er the Potomac,
You circumvented Little Mac,
Oh, may I never know your lack,
Maryland, my Maryland!

J.E.B. Stuart would go on to have many more storied engagements that would be retold for years. But he himself would not last the war. On May 11, 1864, he rode off in the vicinity of Yellow Tavern, just above Richmond, astride not Maryland but a strong, stout gray horse named General. As commander of 4,500 troopers, it might have seemed an easy task to turn the enemy. But on May 11, they faced more than 10,000 determined Federals with heavy artillery in tow. The shot that ended it for General J.E.B. Stuart was fired by a dismounted Union cavalry private and former sharpshooter named John Huff.

Stuart did not die right away. He was carried by bumping and crashing ambulance to his brother-in-law's home in Richmond. As he lay dying, he gave particular requests for the distribution of his property: his golden spurs to General Lee's wife and his horses to his officers. He urged his most heavily built officer to take his largest horse, for "he will carry you better."

The thirty-one-year-old Stuart was buried in Richmond's Hollywood Cemetery. His widow Flora wore black for the rest of her life.

TURNER ASHBY: THE KNIGHT OF THE CONFEDERACY

Turner Ashby started his career as a knight long before shots were fired at Fort Sumter. As Renaissance festivals are the fashion these days, so it was that in the 1850s young people crowded to local fairgrounds to watch recreations of romantic medieval times, complete with jousting.

Mr. Turner Ashby of Rose Hill farm in Fauquier County usually rode a white stallion to these festivals, which were held at Warrenton's White Sulphur Springs. Part of his duties as the successful "Knight of the Black Prince" was to crown the season's Queen of Love and Beauty.

According to Douglas Southall Freeman, he had an air of mystery about him—charisma that would serve him well in battle. His complexion was so dark it was reminiscent of an Arab's, his dark eyes were deep set, his voice soft spoken.

By 1859, Ashby was convinced that real battles were on the horizon and organized a volunteer cavalry company. His reputation for unusual agility, strength and courage drew to him "every boy in the Shenandoah Valley who loves horses and craves adventure," according to his biographer, Major Jed. Hotchkiss.

The Thoroughbreds Join the Cavalry

The sometime Knight of the Black Prince didn't waste any time. Hotchkiss records that on April 16, 1861, Ashby was in Richmond "with other bold spirits" to plan the capture of Harpers Ferry. The next morning—the day of the passage of the Virginia Ordinance of Secession—he returned to Rose Hill to call out his cavalry company.

His deeds soon made him a legend; Thomas "Stonewall" Jackson said that "he never knew his [Ashby's] superior as a partisan leader." But Ashby also had another talent that added to his reputation for bravery and drama. Alone and in disguise, he made a daring visit to Chambersburg, Pennsylvania, and gained complete information about the Federal forces in the area.

Turner Ashby's beloved brother Richard died on June 26, 1861, fatally wounded during a Federal ambush. From that day on, Ashby wanted thorough revenge for the loss of his brother's life.

Ashby was to have only a year to capture the imagination of the press and the people as he rode his white stallion into battle. In June of 1862, just a few days after he made the rank of brigadier general, Ashby's horse was shot out from under him in a charge. He continued on foot, shouting, "Charge, men. For God's sake, charge!" until a musket ball finished him, killing him instantly. He left behind grieving Confederates, including Stonewall Jackson. He was laid to rest in the Stonewall Cemetery in Winchester, Virginia, next to his brother.

THE IRREPRESSIBLE IRISH BRIGADE

Wars are filled with days and nights of exhausting, exciting, dangerous encounters. But then there are also the long-term encampments—weeks or months when it seems absolutely nothing is happening. For hundreds of men in the Union's Irish Brigade, Saint Patrick's Day of 1863 was an occasion to make merry. They had had dirges enough already.

Only the year before, some of the new recruits had been worried that the war might end before they had a chance to meet the enemy in the field. These sons of Erin were true fighting Irish, and they were spoiling for a donnybrook. What they saw as they marched through the wasted Virginia countryside was sobering, though. The men were away fighting, and many of the slaves had sought refuge with the Federal troops as contraband. Spread before the Army of the Potomac were fields overgrown with brambles, lying

unsown. At the farmhouses, they met women and children thin with hunger. One soldier remarked that the scene reminded him terribly of famine days in the Old Country. Surely they could whip such an army.

Yet all the butter, beef and eggs in the world couldn't make up for one foolish commanding officer. Union General Ambrose Burnside brought his troops to Fredericksburg in November of 1862. They were ready for action, but the general did nothing but wait on the other side of the Rappahannock River in Stafford County. He waited through November and into December. While he waited, Lee and his generals entrenched on the high ground, devising excellent fortifications.

Burnside's generals knew what Lee was about, and they assumed that their army would continue to rest until spring and then try another crossing point. No one but a fool or a madman would make the approach on Lee's forces thus fortified. But the orders came. First the troops crossed the river on pontoon boats. They made their way to the center of town, where they infamously looted the houses and businesses. The next morning, before the battle, they were met in the street by undertakers. These enterprising and often prophetic gentlemen passed out business cards to their future clients, guaranteeing quick shipment home.

The Battle of Fredericksburg was a massacre for the Irish Brigade. They went bravely into battle, playing the pipes, singing their songs and carrying their company banner—a flag marked with a bard's harp on a green field. According to Paul Jones's book, *The Irish Brigade*, out of the 1,300 men who went into battle, 545 were killed, wounded or missing, presumed dead. It was a bloody massacre for the Union all around, but even that defeat was not without its moment of solidarity between Irishmen, North and South.

The Federal forces had retreated across the Rappahannock when a wounded figure came out of the dark, bearing their tattered flag, captured in the rush of battle. It was an Irishman—a Confederate Irishman. He had braved the lines and the river to perform this bit of courtesy to his fellow Irish. He was invited to stay, but no, he could not. His loyalties lay elsewhere. Quiet arrangements were made and the gray-clad soldier was returned in due course to his unit.

The brigade was still across the river in the weeks leading up to Saint Patrick's Day, and clearly they intended to stay there a while. Out on a nearby field, great preparations were underway. Construction crews were busy assembling…a racecourse. Not a fort or an earthworks, but a racecourse so that "Saint Patrick's Day in the army" could be celebrated with style.

The Thoroughbreds Join the Cavalry

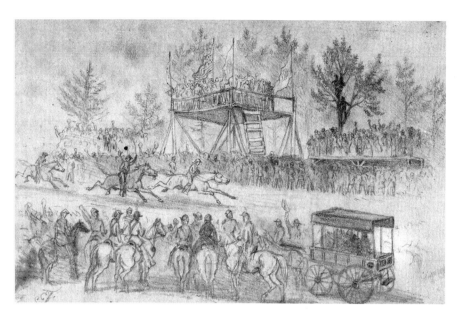

St. Patrick's Day in the army—The grand stand, by Edwin Forbes. *Courtesy of the Library of Congress.*

All the trim and posh decorations that the troops could muster for such an important day were in place. They built a church so soldiers could hear a proper St. Patrick's Day Mass said by a Jesuit priest. They laid out a regular racecourse and built a grandstand for important visitors. The course was something special. It was marked out by flags and ran for two and a half miles over gently rolling ground with "four hurdles four and a half feet high, and five ditch fences, including two artificial rivers fifteen feet wide and six deep; hurdles to be made of forest pine and braced with hoops."

It is estimated that between ten and twenty thousand people came to see the races, featuring "The Grand Irish Brigade Steeplechase," run for a purse of $500. The Confederates were still just across the river, but that did not stop the brigade's jubilation. Eight baskets of champagne, a green tub filled with whiskey punch and sandwiches made from a side of beef, thirty-five hams and a roast pig stuffed with boiled turkeys satisfied their appetites, and the race itself was hardly a disappointment.

First Colonel Van Schack and his lady went over the course in fine style. When the main contest was on, Captain Jack Gosson, a favorite of the brigade, rode General Meagher's gray hunter Jack Hinton to win the race in straight heats. Afterward there were all the games and funning that might

be expected at an Irish country fair: footraces, throwing weights, catching a slippery pig and a contest for the best Irish dancing. The celebrations went on into the night, and the memory of that Saint Patrick's Day in the army was warmly held by the brigade and its friends.

GENERAL LEE AND TRAVELLER

Across the Rappahannock, General Robert E. Lee was planning his next move, as always accompanied by his loyal officers and alongside his legendary horse, Traveller. He had owned Traveller for just over a year. It was at Big Sewell Mountain in southwest Virginia that the general first saw a gray gelding that would become his constant companion through the rest of his life. He was brought to the battle by James W. Johnston, who hailed from Blue Sulphur Springs in what is now Greenbrier County, West Virginia. A promising four-year-old, the gray had won prizes at the local fairs in 1859 and 1860.

Some say he was an American Saddlebred, descended from Gray Eagle, the Kentucky horse who was beaten by Wagner in that long-ago match race. Others, such as Fairfax Harrison, conjectured additional hallowed ancestors for Traveller by virtue of his mother's name:

> *The breeding of Traveller is thus left in confusion, but it seems reasonably certain, nevertheless, that if not eligible for registration he was infused with as good horse blood as there was in Virginia. The evidence suggests, indeed, that on both sides he descended from imp. Diomed. Whether his sire was a Gray Eagle or a Good's Arab (there was no "imported" Arab), he would have derived on that side from Diomed's son, Sir Archie; while the name of his dam (Flora) suggests descent from another son of Diomed, Fall's [sic] Florizel, through one of the many Floras of that breeding recorded in the Stud Book.*

When Captain Joseph M. Broun, the quartermaster of the Third Virginia Infantry, was directed to buy "a good serviceable horse of the best Greenbrier stock for our use during the war," he purchased Jeff Davis from Captain Johnston and renamed him Greenbrier. Lee bought the gray from him in February 1862, en route to South Carolina, for $200.

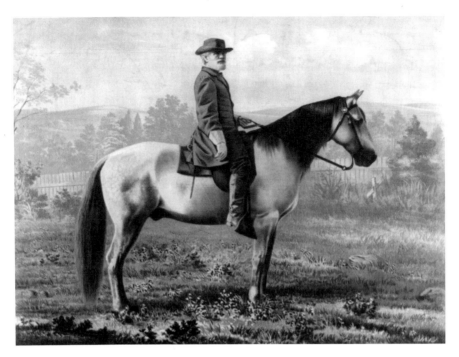

Genl. Lee on Traveller, Hoen. *Courtesy of the Library of Congress.*

He renamed him Traveller, a name rich with Virginia racing lore, namely Morton's (imported) Traveller, who was sire to Tasker's Traveller and Tayloe's Traveller. Those three have faded from the memories of all but the most determined turf historians. Lee's Traveller, on the other hand, is a watchword to the most casual Civil War buff. This Traveller ran no races for Lee, but his paces were remarkable, as remembered by Captain Broun's brother, Major Thomas L. Broun:

> *(Traveller)…was greatly admired in camp for his rapid, springy walk, his high spirit, bold carriage, and muscular strength. He needed neither whip nor spur, and would walk his five or six miles an hour over the rough mountain roads of Western Virginia with his rider sitting firmly in the saddle and holding him in check by a tight rein, such vim and eagerness did he manifest to go right ahead so soon as he was mounted.*

Lee had other horses, but Traveller was by far his favorite. Traveller replaced Brown-Roan, or the Roan, another West Virginia horse that went blind in

137

1862 and had to be retired to a nearby farm. Of his other mounts, Lucy Long was the most constant. She also finished the war with her master, ending her days with the Lee family, along with another mount named Ajax. His bay stallion named Richmond died in 1862 after the Battle of Malvern Hill.

Robert E. Lee was born in the heart of old Tidewater at Stratford Hall. He was the younger son of "Light Horse Harry" Lee—the same Lee who found the shipwreck survivor Ranger for General George Washington during the American Revolution. His father's spendthrift ways left the family in poverty—so much so that it was impossible for Robert to follow his older brother to Harvard.

For him it was West Point. He led the cadet corps, was second in his class and earned not a single demerit, all the while remaining a very popular student. In 1831, he married Mary Anna Randolph Custis. She was the only daughter of Martha Washington's grandson, George Washington Parke Custis.

Robert E. Lee served in the Mexican-American War as an engineer, but his tactical genius and cavalry skills captured the attention of General Winfield Scott. By 1861 he was so well regarded that President Abraham Lincoln offered him command of the Union army. After long consideration, he decided he could not go to war against his own people and tendered his resignation.

He was a brilliant and inspiring commander to his Confederate troops. To his family he was a loving father and husband. And he is also known to have had a special affection for animals, including his daughters' many cats. Yet his boon companion was always Traveller. In a book entitled *General Robert E. Lee after Appomattox*, students who knew him in those postwar years at Washington College—now Washington and Lee University—again and again told of how much his war horse meant to him. As student John B. Collyar recalled:

> *The old iron-gray horse was the privileged character at General Lee's home. He was permitted to remain in the front yard where the grass was greenest and freshest, notwithstanding the flowers and shrubbery. General Lee was more demonstrative toward that old companion in battle than seemed to be in his nature in this intercourse with men. I have seen him, as he would enter his front gate, leave the walk, approach the old horse, and caress him for a minute or two before entering his front door, as though they bore a common grief in their memory of the past.*

The Thoroughbreds Join the Cavalry

The Lexington blacksmith remembered that Lee would always bring the horse to be shod himself, and he would talk to the horse all the while and tell the blacksmith, "Have patience with Traveller; he was made nervous by the bursting of bombs around him during the war."

Lee rode out on Traveller every day in all kinds of weather. Solitary rides seemed to suit them best. It was not unusual to see them taking the path to Peaks of Otter. Lee would be clad in his double-breasted gray coat buttoned to the throat, with gauntlet gloves and top boots.

When a new president's house was built, Lee was particularly pleased that the adjacent stable, linked by a covered walkway, brought him and Traveller "under the same roof." When bitter winter settled on the valley, he found his only pleasure in evening rides, where he could be alone with his thoughts. Even mud did not deter them from their rides. On the contrary, Lee found such tough exercise conditions beneficial to his health.

General Lee only lived for five years after the war, so it is surprising that many of his students shared fond memories of him, but this they did. He made a positive example for them as long as he could. It was a heart condition that did him in at last, and he lingered for some days. Lee's doctor tried to inspire him to recovery by mentioning that Traveller desperately needed exercise. But Lee was probably too far away in his own thoughts to reply. Certainly his last thoughts were of the war and the times he shared with friends, for his final words were, "Strike the tent."

Lee's funeral was quietly grand and was attended by all the school. Traveller was a featured mourner. His saddle and bridle were covered with black crepe fabric, and he followed behind the hearse, led by two old soldiers dressed in civilian clothes. Of course, in due time Traveller joined his master. He was buried properly and honorably, but at some point his bones were disinterred and his skeleton was put on display. Traveller's old bones remained a tourist attraction until 1972, when his remains were reburied by the college chapel near the general and his family.

A WARTIME ENCOUNTER CHANGES RACING HISTORY

In the previous accounts, gallant Virginia steeds fought alongside their masters, shedding blood and sharing adventures during four years both amazing and terrible. But the future of Virginia Thoroughbreds was also

decided around those campfires. The war brought together Southern soldiers from every state into the heart of Virginia for the Shenandoah Valley and Gettysburg Campaigns.

Richard Johnson Hancock hadn't come from a family of horsemen. His family had known hard luck, but young Richard Hancock had worked diligently and was about to become a lawyer when the war swept into his Louisiana town. It was possible in those days—as it still is in Virginia—to become a lawyer through an apprenticeship, by "reading the law" under the direction of an experienced attorney and then taking the state bar exam.

Richard Hancock was a third lieutenant in the Bossier Volunteers by the time he came to Virginia as part of Thomas "Stonewall" Jackson's Shenandoah Valley Campaign. It was here that he was impressed by a fine chestnut gelding owned by a Virginia officer. He and the officer talked for some time about Thoroughbreds and in particular spoke of the officer's neighbor and friend Thomas W. Doswell of Hanover County. Major Doswell's Bullfield Stud had produced such winners as Planet, Nina and Sarah Washington. Bullfield was also responsible for the officer's fine chestnut gelding. Richard's new friend suggested he visit Bullfield after the war. He was sure that Hancock and the major would get along well.

But there was still a war to fight, and as is recorded in fascinating detail in the Hancock family history, *From Here to the Bugle*, Richard Hancock was shot, promoted, shot again, captured, escaped and married. Between the promotion and the second injury (a serious stomach wound), he courted a young lady named Thomasia Overton Harris of Ellerslie near Charlottesville. Thomasia's mother had named the farm in honor of the estate of Sir William Wallace, the Scottish national hero featured in the movie *Braveheart*. Ellerslie was not a racing stable. That would come later. In its early days, the 1,450-acre farm was used for raising the usual crops and livestock, including carriage horses.

The war ran on and eventually the Confederates' luck ran out. It was officially over on April 14, 1865, when Robert E. Lee presented his sword to Ulysses S. Grant at Appomattox Court House. Grant returned him his sword and gave another important concession: "Officers are to retain their side arms, their horses, when they own them, and their private baggage."

After the war, Richard Hancock, now Ellerslie's owner, could make good on his intention to visit Major Doswell. The two became partners, buying, selling and breeding blooded horses during the last years of the nineteenth

century. Captain Hancock and his entire family worked Ellerslie as a regular farm. But through the years he was able to purchase a few fine Thoroughbreds. His first mare was a Kentucky-bred named War Song (1867–1887), who is commemorated in a portrait by Civil War artist John Elder.

Mare by mare, Richard Hancock built up a very respectable establishment. He tended to have one significant sire at a time—first Scathelock and then Eolus. He swapped out the one for the other in a prudent move to provide fresh bloodlines for his stable. He had common sense, good luck and worked hard. Richard Hancock soon enough had a Preakness winner to his credit, Knight of Ellerslie. Another great was Eolite, who was renamed Saint Saviour.

After the war, the large, formal race meets had left Virginia. It was still possible to racehorses at county fairs, as the Hancocks and many other farmers did, and those were well attended and enjoyed by the locals. With strawberry soda, lemonade, fortunetellers and knife sellers, these old-fashioned fairs were almost a nod back to colonial racing days.

In 1886, two young Hancocks climbed on a train to join their father, the captain, at the Preakness Stakes. Knight of Ellerslie had already had his year, but this time two Ellerslie colts, Eolian and Eurus, were in the field. The boys arrived past midnight ravenously hungry. Their father and Major Doswell sweet-talked a waiter into opening the hotel kitchen for them. The country-bred boys feasted on huge portions of deviled crab, coconut pie, strawberries and cream.

Unlike a certain lobster-loving Napoleon of the Turf more than fifty years previously, these race-goers had strong stomachs and were ready to face the next day in fine condition. Sadly, neither Ellerslie colt won, and Captain Hancock had to sport some of his neighbors their train fare for the ride home. Captain Hancock himself never bet on his horses. His game was breeding and selling the beauties, which had a much more reliable profit margin. This natural prudence would be put to the test when the national racing scene met its darkest days in just a few years.

The Racehorse Region Rebounds

The late 1800s were exciting times for Virginia horsemen. They discovered that peacetime Yankees appreciated Virginia yearlings as much as wartime Yankees had—the difference being that this time around they were willing to pay top dollar for them at the Saratoga sales. Virginia trainers and jockeys were in demand. All of the cleverness and skill of the sons of the Old Dominion would be called upon to keep racing alive during its darkest years.

THE BOY WONDER

James Rowe (1857–1929) worked as both jockey and trainer for the top stables of his time—and he got an early start at it. Born in Fredericksburg, James was ten years old and working hard selling newspapers and exercising horses at the Exchange Hotel in Richmond when he was hired as a jockey by Colonel David McDaniel. Young Rowe celebrated his first win with a stick of striped peppermint candy and permission to stay up until nine o'clock that night.

In 1871, he turned fifteen and become America's leading rider. He held that title for two more years, winning the Saratoga Cup in 1872 astride Harry Bassett. That same year and the year following, he rode to victories in the Belmont Stakes. The lad declared his independence from Colonel McDaniel mid-season of 1874 and found he was unable to race.

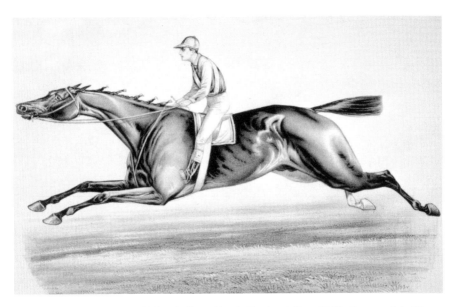

The great racing crack Hindoo, (Trained by James Rowe). Currier & Ives, 1881. *Courtesy of the Library of Congress.*

Rules declared that he could not ride for another employer that year, so James Rowe very sensibly joined the circus, as part of P.T. Barnum's famous Hippodrome.

He returned to racing as soon as he could, but this time to work as a trainer, for he had outgrown the jockey's role. Rowe went on to train stars for the Dwyer brothers' stable in Brooklyn: Luke Blackburn, Miss Woodford and Hindoo. He worked with August Belmont and conditioned the Keene racing stable and those of other owners, polishing the brilliance of Sysonby, Commando, Maskette, Sweep, Peter Pan, Whisk Broom II and the undefeated Colin. James Rowe thought so well of the last named horse that he said he would like just three words on his headstone: "He trained Colin."

Robertson credited James Rowe with being the cement that held racing history together during a shaky transition period. And this we do know: he was greatly admired by his fellow horsemen. On August 2, 1929, James Rowe passed away. Saratoga Race Course gave him a unique honor—for the first time, the flag was flown at half-mast out of respect for a horse trainer.

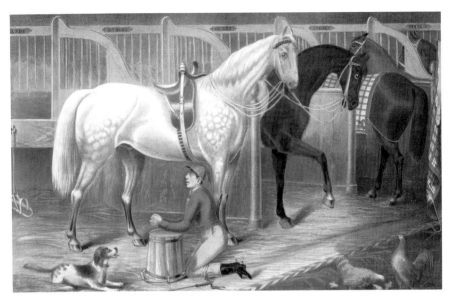

The jockey's prayer, by Rae Smith. *Courtesy of the Library of Congress.*

THE JOCKEY CLUB TAKES THE LEAD

The 1890s saw the end of the wild days for big tracks. New York's Jockey Club combined with the Board of Control to bring order to racecourses. The Jockey Club set rules nationwide, licensing trainers and jockeys—what a far cry from the colonial and antebellum days!—and allotting racing dates. But as in the old days, the Jockey Club, much as the local clubs before it, was made up of leading business, sporting and political figures, and they wielded their national authority with great determination. Any of the tracks that refused to accept their rules were considered "outlaw." A horse that ran on an outlaw track was considered an outlaw until he was officially reinstated by the club. At one point, more than twelve hundred horses were on the outlaw list.

In 1896, the club took over managing the *American Stud Book*, which had been the project of Virginians and North Carolinians so many years ago. It also instituted a clever, standardized identification system. On the inner part of horses' legs there are rough patches, called chestnuts (not to be confused with the color). They are residual thumbs left over from eons ago when equine ancestors ran on their many splayed toes. Those chestnuts take as

unique a fingerprint as a human's, making it much harder for owners and trainers to throw a ringer into a race. Today lip tattoos are also used to positively identify horses.

THE VIEW FROM THE CAMP MEETING, OR THE NEW YORK BLACKOUT

The tracks were going well, large and little, and especially so in New York State, where gambling brought in lots of revenue. Saratoga was the place where Virginia breeders such as the Hancocks and Major Doswell sent their yearlings to bring in top dollar. But trouble was brewing alongside the coffee in the homey kitchens set up adjacent to the old training barns.

The Jockey Club may have controlled the tracks, but it did not have a hand in all the moneymaking schemes that came along with them. Although the Thoroughbreds might be handsome, to a certain very vocal segment of the voting public, they were simply handsome limbs of Satan. With the racing scene came gambling, drinking and other vices. Early 1900s America was experiencing a religious revival, and everyday citizens took it upon themselves to lobby their state legislatures to ban the sport.

In New York, they succeeded. The reformers elected Governor Charles Evans Hughes specifically so that he would repeal the law that allowed wagering at tracks, which he did in 1908. This was a disaster for breeders across the country. With no wagering in the Empire State, demand for young bloodstock fell, and prices dropped alarmingly. Some breeders got out of the business altogether, holding fire sales for what should have been top-priced stock. The ban only lasted two years, but it was enough to damage the industry and weaken its reputation worldwide, although American stables continued to rack up victories in Europe.

THOSE "FREE-HANDED AND CLEVER AMERICAN BREEDERS"

Although the repercussions of the New York Blackout would be felt for years in Virginia, Kentucky and other states with a vested interest in horse racing, the Hancocks tightened their belts, culled their broodmare herd to the bone and got through it. These later years were when young Arthur B. Hancock

ran two stables: the old homeplace at Ellerslie near Charlottesville and a new farm called Claiborne deep in the heart of Kentucky bluegrass. Like his father, Arthur Hancock found true love in horse country with Miss Nancy Clay. Her family had run a small stable of racehorses for years. The couple traveled by train to honeymoon in Hot Springs, Virginia—the same resort where John Randolph had slandered Sir Archie's ancestry almost a hundred years before.

The Hancock family was very selective as to which sires they purchased, and they were not averse to putting up serious money for an excellent horse. For $20,000 they purchased Celt, a fine racer trained by James Rowe. He had been retired early due to an injury, but he went on to be a national leading sire in 1919. Celt stood at Ellerslie.

The Hancocks and other breeders benefitted hugely from a snobbish rule imposed by the English Jockey Club in 1913: "No horse or mare can, after this date, be considered eligible for admission to the General Stud Book unless it can be traced without flaw on both sire's and dam's side of its pedigree to horses and mares themselves already accepted in the earlier volumes of this book."

By those lights, the incredible American racehorse Man o' War was no true Thoroughbred, and a lot of newly designated English "half-breeds" didn't make the bloodline requirements to be proper blooded horses—at least as far as the toffs were concerned. The Hancocks, like those venerable Virginians before them, knew a bargain when they saw it and pounced, adding excellence to their stables at very reasonable rates.

But it wasn't just marked-down half-breeds that interested Mr. Hancock. In these early years, he managed a deal with the "Primrose Earl" of Roseberry to acquire his excellent stallion Wrack, winner of the Epsom Derby and also a good steeplechaser. Philip Primrose, Earl of Roseberry, declared when he was a young man that someday he would marry the richest girl in England, become prime minister and own an Epsom Derby winner. He married the heiress Hannah Rothschild, and in 1894 he became prime minister. Wrack was one of his several Derby winners, and the earl was not keen on parting with him. However, his parish church stood in need of serious repair, and the earl decided to apply the stallion's purchase price to the project. His English trainer, Frank Hartigan, mourned his loss: "Wrack was one of the most tractable horses that ever trod the turf. He was a Christian."

Wrack certainly did his duty by Claiborne Farm by becoming a leading sire of money winners. Hancock's French import, Sir Gallahad III, also

produced amazing colts. He was purchased by a syndicate of breeders, including William Woodward of Belair Stud in Maryland. When Celt's filly Marguerite was bred to Sir Gallahad, she produced one of the finest horses of his time—Gallant Fox, a Triple Crown winner. His jockey, Earle Sande, said of the Fox, "My Derby win on Gallant Fox was the easiest of the three I've had. I had to struggle to get Zev and Flying Ebony home in front, but I only had to sit still on Gallant Fox."

When another Epsom Derby winner named Blenheim II came on the market, Mr. Hancock again created a syndicate of leading owners, including Marion duPont Scott and Calumet Farm, for £45,000 sterling. Originally bound for Ellerslie, Blenheim II would stand at Claiborne in the company of many impressive stallions, not all of them owned by the Hancocks. Imported Princequillo, the grandsire of Secretariat, was in the barn. Although owned by Prince Djordjadze of the then-Soviet Republic of Georgia, the stallion was bred on shares and housed at Claiborne Farm. He was originally at Ellerslie, which was finally sold out of the Hancock family in 1946.

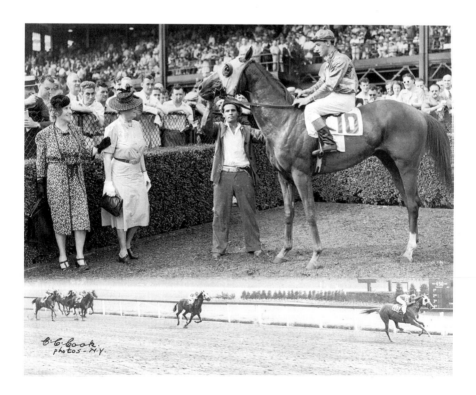

Time o' War wins his race. *Courtesy of Stratford Hall.*

The Virginians' efforts did not go unnoticed across the Atlantic. Lady Wentworth, writing in her small but fascinating book *British Horses and Ponies* in 1948, lamented: "We must, however, beware lest we lose our hardly won supremacy and allow the war and the free-handed and clever American breeders and other buyers to skim the cream from our stock."

Ellerslie was not the only Virginia farm producing racing Thoroughbreds in the twentieth century. In nearby Esmont, the Van Cliefs' Nydrie Stud was sending yearlings to the Saratoga sales, too. North Wales Farm, Blue Ridge Stud, Canterbury Farm and Grafton Farm were just a few of the other breeders near Warrenton. The Fauquier County area, famous today for its Gold Cup Steeplechase, was home to Mrs. Sloane's Brookmeade Farm and William Ziegler's Burrland stud.

In the Tidewater region, the Lee family's historic Stratford Hall brought back Thoroughbreds in a modest way during the 1930s, though the estate was no longer in the Lee family. In 1935, two Thoroughbred mares were brought to graze in the old pastures alongside a half-bred. Major General B.F. Cheatham said the goal was to produce quality horses of the sort that would have appealed to the Lee family, whether they were hunters or racers. Both the Thoroughbreds were sent to Man o' War's son, Dress Parade, and in a few years Time o'War was racing in the money for Stratford Hall.

Old Bones Comes to New Market

The 1918 Kentucky Derby was supposed to be a shoo-in for Willis Sharpe Kilmer's Sun Briar. Mr. Kilmer had made his millions from a top-selling patent medicine called Swamp Root. He had been breeding and racing harness horses for some years, but now he was turning his attention to Thoroughbreds. Bred to the clouds, as they say, the French import Sun Briar proved to be a champion two-year-old. Sun Briar was so prized by Mr. Kilmer that he created the magnificent facility Sun Briar Court in New York State to honor his majesty and host his mares. Not so prized was his stablemate, Exterminator. This raw-boned chestnut gelding was not beautiful, but he was game, and when Sun Briar had to be pulled from the Kentucky Derby at the last minute, Exterminator stepped up, took the lead and won the roses.

Sun Briar soon retired to a lengthy stud career, but Exterminator raced on for years, earning the nickname "Old Bones the Wonder Horse" and the public's affection. Eventually the two cropped grass in Virginia, for Mr. Kilmer's breeding interests had outgrown Sun Briar Court. He bought an old farm in New Market near Lexington and built it into a showplace called Court Manor Farm. It was a successful horse operation for many years until its owners' deaths. Today, Court Manor is home to a top breeding operation for beef cattle.

Shuvee Shows Them How It's Done

Down in Doswell, Virginia, Christopher Chenery was rebuilding the family racing stable, the Meadow, a few broodmares at a time. He had tremendous luck in that he, like a certain Major Doswell before him, had become friends with the Hancock family. Though they were now firmly rooted in Kentucky, the Hancocks kept up their Virginia ties. Princequillo, standing at Claiborne, had covered the Meadow's Hildene several times and none of the foals was a disappointment.

One of the finest was Hill Prince, who went on to become voted best three-year-old by many groups and 1949's Horse of the Year. He also won the Jockey Club Gold Cup. About seventeen years later, a chestnut filly was born at Morven in Albermarle County on property that had once been part of Ellerslie. The filly's name was Shuvee, daughter of Hill Prince, and she became only the second filly to win the Triple Tiara—the fillies' version of the Triple Crown, including the Selima Stakes. Shuvee was herself a descendant of the famous Selima.

Years before Ruffian had her ill-fated match race to prove she was as good as the boys, Shuvee showed them how it was done, winning the 1970 Jockey Club Gold Cup over two miles, just as her sire had years before. She won it again in 1971, by seven lengths. It was her last race before retirement.

Shuvee came back to Morven Stud to serenades, champagne and sugar cubes. Alfred G. Vanderbilt, chairman of the New York Racing Association, presented her owners with a plaque listing her accomplishments, and a toast: "To a hell of a mare!"

THE GREAT SECRETARIAT

In 1973, the country was held spellbound as a giant red stallion swept the Triple Crown, setting blazing speed records along the way. He was a wonder horse, this descendant of Princequillo, Sun Briar, Lexington, Boston, Sir Archie, Diomed, Shark, Medley and all three foundation sires. Centuries of careful breeding came together in a foal born not in Kentucky, but deep in the heart of the old Horse Race Region at the Meadow Stable in Doswell, Virginia.

Secretariat was a cousin to Shuvee—both had Princequillo as their grandsire. He had her speed and then some. When he came out to the track as a two-year-old, rail birds had a hard time believing he was just a youngster. The red horse was phenomenally well developed for his age, even if some of it was baby fat. Unlike many of his red-coated relatives—among them Fair Play and Boston—Secretariat was a sociable fellow. Perhaps a little too sociable, as he had a tendency in his early races to play when he should have been concentrating on the finish line.

But by his third year, he was well on his way to being a phenomenon. Seth Hancock was only twenty-three years old when Secretariat's owner,

Secretariat as a foal, by Sidney E. King. *Courtesy of Union Bank & Trust, Bowling Green, Virginia.*

Penny Chenery, gave him the job of creating a multimillion-dollar syndicate to purchase the colt's breeding rights. His father had passed on only a little while before, as had Penny Chenery's father, Christopher. This deal was done before Secretariat won the Triple Crown and set his still-standing world record for 2:24 for one and a half miles on dirt in the Belmont Stakes.

Secretariat retired to stud that same year at Claiborne Farm. His blood runs in some stakes winners, including the 2004 Kentucky Derby and Preakness winner, Smarty Jones. Like his many times back grandsire Shark, he is known as a better broodmare sire. Some have speculated that this is explained by genetics—that he and his nearest rival Sham carried an x-factor gene through their female lines that made for incredibly large hearts and correspondingly excellent track records.

Though his physical heart was huge, he also had the quality horsemen refer to as heart—the drive to win that separates champions from the rest of the field. As his owner Penny Chenery said, it was Secretariat's great courage in competition and delight in running, as well as his huge pumping heart, that made him "the greatest."

FROM HUNT FIELD TO RACE FIELD: THE STEEPLECHASE RACES

There's much talk these days of extreme sports, and riding at breakneck speed over tall fences is every bit as dangerous and exciting as more modern sports. The steeplechase is a sport with its roots in the fox hunt—another popular pastime with many Virginia horsemen, including George Washington, Thomas Jefferson and J.E.B. Stuart. Stuart enjoyed it so much that he tried to fit in a chase during downtimes between the battles. For a glimpse at Virginia racing's roots, history buffs would do well to take in a steeplechase.

According to the Virginia Steeplechase Association, the first recorded steeplechase with more than two horses in the field took place in England in 1792. This kind of racing was another sporting custom brought over to anglophile Virginia. White Sulphur Springs resort near Warrenton was the playing field for tournaments in the medieval tradition. It was also home to steeplechases as early as 1844. Steeplechases are often held over brush fences with solid bottoms and brush tops that horses can sail through quickly, without having to arch their backs as they must over more traditional jumps.

Probably the most famous steeplechase in the world is England's Grand National at Aintree. As it happens, the first American-bred and American-owned horse to win the Grand National was from Virginia. It was Marion duPont Scott's Battleship—a son of Man o' War—who leaped to victory there in 1938.

The duPont family had purchased President James Madison's old home Montpelier in 1901 and horses featured prominently in Marion duPont's childhood. At first she was interested in carriage horses and show ring equitation. She was the first lady not to ride sidesaddle for the Madison Square Garden horse show. While growing up in Virginia's hunt country, she became absorbed in field equestrian sports.

In 1928, she and her brother William duPont Jr. inaugurated the Montpelier Hunt Races, an important event on the National Steeplechase Association's circuit. The race continues to be held yearly on the first Saturday in November and always draws a huge crowd of horse enthusiasts. Marion duPont Scott—she had been married to Hollywood film actor Randolph Scott—also ran the Camden Training Center in South Carolina. Upon her death in 1983, she endowed the Marion duPont Scott Equine Medical Center at Morven Park in Leesburg, Virginia.

Although many steeplechase races are held throughout the season—from March through November—there are two meets held at Great Meadow near the Plains, Virginia, that garner a lot of attention. The Virginia Gold Cup races are held every May and host over forty-five thousand people. This is run for a solid four miles over four- and five-foot timber fences. Besides the main event, there are also terrier races and a gathering of vendors for onlookers' enjoyment. Come October, the International Gold Cup is run at the same facility over a four-and-a-half-mile brush course that is very similar to the one jumped at Aintree.

RIDERS UP AT COLONIAL DOWNS

Racetrack gambling was a long time in coming back to Virginia, but on Labor Day in 1997, Colonial Downs opened its first season. Colonial Downs is located in New Kent County, Virginia, off Interstate 64 between Richmond and Williamsburg. Its managers have designed some classic races to attract top owners and jockeys. Thoroughbreds race at Colonial Downs

from June to the beginning of August, with the $.5 million-dollar Virginia Derby held in July. The Colonial Turf Cup, held on the track's Secretariat Turf Course, is part of the $5 million Jacobs Investments Grand Slam of Grass. This race is a nod to those early Virginia turf races. Running on grass is still very popular in Britain.

Harness racing has its season at Colonial Downs from mid-September through early November. In April, the track plays host to the famous Strawberry Hill Races. These steeplechases, once run through the streets of Richmond and at nearby Strawberry Hill Farm, consist of six races. The most famous is the $25,000 Strawberry Hill Classic.

VIRGINIA RACING: YESTERDAY, TODAY AND TOMORROW

Sometimes the past is more than prologue—it can also be epilogue. As the twenty-first century unfolds, a number of modern developments echo the old Racehorse Region's storied history.

In 1751, Carter Burwell built a fine home called Carter's Grove overlooking the James River near Williamsburg. In 2009, a twenty-first-century owner is planning an ambitious equine operation to make Carter's Grove a place where, once again, horses will be bred to run.

Racing will return to Caroline County soon after the Meadow Event Farm opens in 2009. As the new site of the Virginia State Fair, Secretariat's birthplace is the projected home for the Strawberry Hill Races. Crowds will gather once more to witness the excitement as brave horses take on their competition.

Meanwhile, halfway around the world, the Virginia racing blood has come full circle. Sheikh Mohammed of Dubai, one of the richest and most powerful men in horse racing today, has collected some of the finest Thoroughbreds in the world for his racing, breeding and training operations, which are named for the three Thoroughbred foundation sires: Darley, Byerley and Godolphin. Many of these prized stallions and mares trace back to Diomed, Medley, Sir Archie, Boston and Selima—a royal flush of the Old Dominion's racing dynasties.

Selected Sources

Alvey, Edward, Jr. *The Fredericksburg Fire of 1807*. Fredericksburg, VA: Historic Fredericksburg Foundation, 1988.

The American Turf Register, Sportsman's Herald and General Stud Book.

Anderson, James Douglas, and Baylie Peyton. *Making the American Thoroughbred: Especially in Tennessee, 1800–1845*. Norwood, MA: Plimpton, Press, 1916.

Blanchard, Elizabeth Amis Cameron, and Manly Wade Wellman. *The Life and Times of Sir Archie*. Chapel Hill: University of North Carolina Press, 1958.

Bracken, Henry. *Ten Minutes Advice to Every Gentleman Going to Purchase a Horse out of a Dealer, Jockey, or Groom's Stables*. Philadelphia: Joseph Crukshank, 1787.

"Breeders of Fauquier County." *Virginia and the Virginia County* 72, no. 5 (May 1950): 21–26.

Calhoun, Jeanne A. "Philip Ludwell Lee of Stratford: An Eighteenth-Century Virginia Gentleman Entrepreneur." Robert E. Lee Memorial Association, Stratford, April 1992.

Capps, Timothy T. *Secretariat: Racing's Greatest Triple Crown Winner*. Lexington, KY: Blood-Horse Publications, 2007.

Cheatham, B.F. "The Blue Bloods of the Northern Neck." *The Horse*, May/June 1938, 3–5.

Cohen, Ken. "Decoding the Meanings of Thoroughbred Horse Racing in Early America, 1790–1840." Banner Lecture Series, Virginia Historical Society, Richmond, VA, October 18, 2007.

Cooke, John Esten. *Stories of the Old Dominion*. New York: Harper & Brothers, 1879.

Cunningham, Harvey. "When Horse Racing Reigned Supreme in Fredericksburg." *Fredericksburg Times*, March 1976, 5–15.

Daniels, Jonathan. *The Randolphs of Virginia*. Garden City, NY: Doubleday, 1972.

Davis, Burke. *JEB Stuart: The Last Cavalier*. New York: Rinehart & Company, 1958.

Edwards, Peter. *Horse and Man in Early Modern England*. London: Continuum, 2007.

Eisenberg, John. "Off to the Races." *Smithsonian* 35, no. 5 (August 2004): 98–105.

Fabian, Ann Vincent. *Card Sharps, Dream Books & Bucket Shops: Gambling in 19th-century America*. Ithaca, NY: Cornell University Press, 1990.

Fithian, Philip Vickers. *Journal and Letters of Philip Vickers Fithian, 1773–1774*. Charlottesville, VA: Dominion Books, 1957.

Fitzpatrick, John C., ed. *The Writings of Washington from the Original Manuscript Sources, 1745–1799*. 39 vols. Washington, D.C.: Government Printing Office, 1931–1944. Reprint, New York: Greenwood Press, 1970.

Fredericksburg Times, "Early Races at Bowling Green," May 1983, 29.

Gill, Harold B., Jr. "A Sport Only for Gentleman." Colonial Williamsburg Foundation. http://www.history.org/history/teaching/enewsletter/volume4/march06/sport.cfm.

Glueckstein, Fred. "Gen. George S. Patton Jr. and the Lipizzaners." *Army*, June 2006.

Harrison, Fairfax. *The Roanoke Stud, 1795–1833*. Richmond, VA: Old Dominion Press, 1930.

Herbert, Henry William. *Frank Forester's Horse and Horsemanship of the United States and British Provinces of North America*. 2 vols. New York: Geo. E. Woodward, 1871.

Hervey, John. *Racing in America: 1665–1865*. 2 vols. New York: The Jockey Club, 1944.

Hoskins, Charles Willard. *Hoskins of Virginia and Related Families*. Tappahannock, VA: Warner, 1971.

Hotaling, Edward. *The Great Black Jockeys: The Lives and Times of the Men Who Dominated America's First National Sport*. New York: Three Rivers Press, 1999.

Hutcheson, Nathaniel Goode. *What Do You Know about Horses? Mecklenburg County and the Aristocratic Thoroughbreds.* Clarksville, VA: Clarksville Print. Co., 1958.

The International Museum of the Horse at Kentucky Horse Park. http://www.kyhorsepark.com/museum/history.php?chapter=83.

Jennings, Frank. *From Here to the Bugle.* Lexington, KY: Thoroughbred Press, 1949.

Johnson, Ronald W., and Harlan D. Unrau. "Preliminary Historic Resource Study, Chatham, Fredericksburg and Spotsylvania County Battlefields Memorial National Military Park, Virginia." National Park Service In-house Report, 1982.

Jones, Paul John. *The Irish Brigade.* Washington, D.C.: R.B. Luce, 1969.

Jones, Virgil Carrington. *Ranger Mosby.* Chapel Hill: University of North Carolina Press, 1944.

Kernan, Michael. "Around the Mall and Beyond." July 1, 1995. *Smithsonian.com.* http://www.smithsonianmag.com/history-archaeology/letters_07951. html?c=y&page=1.

Lancaster, Robert A., Jr. *Historic Virginia Homes and Churches.* Philadelphia: J.B. Lippincott, 1915.

"The Late Confederate General J.E.B. Stuart." *Harper's Weekly*, August 6, 1864, 509–10.

Mackay-Smith, Alexander. *The Thoroughbred in the Lower Shenandoah Valley, 1785–1842.* Winchester, VA: Piper Printing, 1948.

Markham, J., G. Jeffries and Discreet Indians. *The Citizen and Countryman's Experienced Farrier.* London and Wilmington: James Adams, 1764.

Meade, William. *Old Churches, Ministers and Families of Virginia.* Philadelphia: J.B. Lippincott, 1872.

Moreau de Saint-Mary. *Horses in America: Essay on the Manner of Improving the Breed.* Philadelphia: Moreau de Saint-Mary, 1795.

Mosby Heritage Area Association. http://www.mosbyheritagearea.org.

Mosby, John Singleton. *Stuart's Cavalry in the Gettysburg Campaign.* New York: Moffat, Yard and Company, 1908.

Newman, Neil. *Famous Horses of the American Turf.* Vol. 1. New York: Derrydale Press, 1931.

Old and Sold Antiques Auction and Marketplace. "Never Go to a Horse Race." http://www.oldandsold.com/articles01/article921.shtml.

Pearl Technologies. Thoroughbred Horse Pedigree Query. http://www.pedigreequery.com/.

Petruzzi, J. David. "The McClellan Saddle." *Hoofbeats and Cold Steel.* http://petruzzi.wordpress.com/2007/05/30/the-mcclellan-saddle/.

Pollard, Garland. "Where Keswick Began." *Virginia Living* 5, no. 1 (December 2006): 131–35.

Riley, Franklin L. *General Robert E. Lee after Appomattox.* New York: Macmillan, 1922.

Robert E. Lee Memorial Association, Inc. "Stratford Hall Plantation." http://www.stratfordhall.org.

Robertson, William H.P. *The History of Thoroughbred Racing in America.* New York: Bonanza Books, 1964.

Russell, Nicholas. *Like Engend'ring Like: Heredity and Animal Breeding in Early Modern England.* Cambridge: Cambridge University Press, 1986.

Secretariat.com. http://www.secretariat.com.

Shelburne, Anita. "Morven Estate Part of Kluge Package." *The Daily Progress*, May 20, 2001.

Speed, John Gilmer. *The Horse in America.* New York: McClure, Phillips & Co., 1905.

The Spirit of the Times.

The Sporting Magazine or Monthly Calendar of the Transactions of the Turf, the Chase, and Every Other Diversion Interesting to the Man of Pleasure, Enterprise and Spirit.

Standard, Mary Newton. *Colonial Virginia: Its People and Customs.* Detroit: Singing Tree Press, 1970.

Struna, Nancy L. "The North-South Races." *Journal of Sport History* 8, no. 2 (1981): 28–57.

Stuart, Hugh Roy. "Historic Landmarks of King George County, Virginia." 1962.

Thoroughbred Bloodlines. "Early Stud Book." http://www.bloodlines.net/TB/Notes/EarlyStudbook.htm.

Thoroughbred Heritage. "Foundation Sires." *Historic Sires.*
http://www.tbheritage.com/HistoricSires/FoundationSires/FoundSiresChron.html.

———. "The Great U.S. Match: Boston vs. Fashion." *Turf Hallmarks.*
http://www.tbheritage.com/TurfHallmarks/BostonvsFashion.html.

Trevathan, Charles E. *The American Thoroughbred.* New York: Macmillan, 1905.

Van Clief, Mr. and Mrs. Daniel G. "Nydrie Stud: 47 Years of Quality at
Saratoga." *Albemarle Magazine,* June/July 1980.

Via, Vera V. "The Boys in Gray: Colonel Hancock of Louisiana Adopted
Albemarle as Home." *Daily Progress*, March 16, 1961.

———. "Looking Back." *Daily Progress*, December 8, 1955.

Wentworth, Lady. *British Horses and Ponies.* London: Collins, 1947.

Wikipedia contributors. "Boston (horse)." Wikipedia, The Free Encyclopedia.
http://en.wikipedia.org/w/index.php?title=Boston_%28horse%29&oldid=18
0766205.

———. "Traveller." Wikipedia, The Free Encyclopedia.
http://en.wikipedia.org/w/index.php?title=Traveller_%28horse%29&oldid=2
05472022.

Wyatt, Edward A. "Newmarket of the Virginia Turf." *William and Mary Quarterly*,
Second Series 17, no. 4 (October 1937): 481–95.

About the Authors

Virginia C. Johnson writes and edits articles as a web content librarian at the Central Rappahannock Regional Library in Fredericksburg, Virginia. She graduated from the College of William and Mary with a degree in anthropology and went on to get her master's degree in library science from the University of Maryland. She and her husband, Steve, have two children, Autumn and Ben.

Barbara Crookshanks, a freelance writer in Fredericksburg, was on the staff of the *Ladies' Home Journal* in Philadelphia, the *Charleston (WV) Gazette* and the *Free Lance-Star* newspaper. Longtime editor of the *Fredericksburg Times* magazine, she holds a degree in journalism from West Virginia University. She and her husband, Robert V. Crookshanks, are the parents of two daughters, Virginia C. Johnson and Lee P. Cotton.

An index to *Virginia Horse Racing: Triumphs of the Turf* is available online at www.gallopinghome.com.